Noah in Ancient Greek Art

Noah in Ancient Greek Art

Robert Bowie Johnson, Jr.

SOLVING LIGHT BOOKS

He is revealing the deep and the concealed things;
knowing what is in the darkness since with Him
a stream of light solves them.

Daniel 2:22

©2007 Robert Bowie Johnson, Jr.

Solving Light Books

727 Mount Alban Drive

Annapolis, Maryland 21409

SolvingLight.com

Computer Renders of the Labors
of Herakles by Holmes Bryant
©2006 Holmes Bryant
and Robert Johnson

TheParthenonCode.com

ISBN 978-0-9705438-4-4

Library of Congress Control Number: 2007905238

All Scripture passages, unless otherwise noted, are from the Concordant Translation, Concordant Publishing Concern, Santa Clarita, CA 91387 (Concordant.org).

Second Printing.

Acknowledgements

Thanks to Fred Coulter, John Anderson, John Rothamel, Frank Bonarrigo, Michael Thompson, David Allen Deal, Theophile Oosterlinck, Pete Lounsbury, Elaine Scott Bridgman, Mark Wadsworth, Joel Osteen, Ron Pramschufer, Nancy Beth Fisher, Lisa Marone, Peggy Griggs, Mark Wadsworth, and Richard Burt.

Thanks also to AnswersinGenesis.org and CreationontheWeb.com.

Special thanks to Dean H. Hough and James R. Coram, of *Unsearchable Riches*, a publication of the Concordant Publishing Concern, for their inspired and enlightening writings.

The reconstruction of the metopes from the temple of Zeus at Olympia by Holmes Bryant depicting the twelve labors of Herakles (Section III) and the colors of the backgrounds and figures (back cover) are based primarily on the work of Georg Treu from the late 19th century and the examination by Nicholas Yalouris, ephor of Olympia in 1967.

The opening of Your words is enlightening,
Making the simple proficient.

<div align="right">Psalm 119:130</div>

For His achievement are we, being created in Christ Jesus for good works, which God makes ready beforehand, that we should be walking in them.

<div align="right">Ephesians 2:10</div>

Thus let a man be reckoning with us—as deputies of Christ, and administrators of God's secrets.

<div align="right">I Corinthians 4:1</div>

CONTENTS

For Nancy Lee

INTRODUCTION

If you've read *Athena and Kain: The True Meaning of Greek Myth* and/or *The Parthenon Code: Mankind's History in Marble*, you're in for a further treat. We go deeper into the true identity of Athena, identifying the real woman she represents—the one who came through the Flood on the ark as Ham's wife. It sounds fantastic, but just wait and see.

In the early post-Flood world, this woman was so influential in promoting the resurgence of the way of Kain (Cain) that every Mediterranean and Mid-eastern culture idolized her, often using different names for different aspects and achievements of this "goddess."

If you haven't yet read my above-mentioned books, you're in for a big surprise in this one. What today's scholars call ancient myth is not myth at all, but rather the history of the human race expressed from the standpoint of the way of Kain. This book is written in such a way that you should be able to pick up and understand this crucial thread very quickly. In most cases, the ancient art speaks for itself. An 8-page summary of the true meaning of Greek myth, "Athena and Eve," can be found under "Features" at SolvingLight.com. It can't hurt to refamiliarize yourself with the first eleven chapters of Genesis.

As the following narrative progresses, you'll see that Noah was not some vague figure remembered by a few maverick Greek artists. Greek vase-artists and sculptors actually defined the rapid growth and development of their contrary religious outlook in direct relation to Noah and his loss of authority. Greek artists portrayed the *victory* of their man-centered idolatrous religion as the simultaneous *defeat* of Noah and his Yahweh-believing children. The twelve labors of Herakles sculpted on the temple of Zeus at Olympia (Section III), in and of themselves, chronicled and celebrated mankind's successful rebellion against Noah and his God after the Flood.

The most important part of this book may be Section IV which explains why the scholarly world remains blind to the obvious and simple historical truths expressed in ancient art. I continue to marvel along with the apostle Paul, and perhaps you will as well: "Does not God make stupid the wisdom of this world?" (I Corinthians 1:20).

9

SECTION I

Background: The Memory of the Adored Woman

In *The Parthenon Code: Mankind's History in Marble*, I show that Greek sculpture and vase-art portray not myth, but rather the history of the human race, a history that corresponds to the Genesis account. The difference is that the Greeks believed the serpent did not delude the first couple in paradise, but instead, enlightened them.

Not only were the events of Eden part of the Greeks' collective cultural memory, their special interpretation of those events made up the very basis of their religious system. Genesis *describes* the key events in human history. Greek art *depicts* the key events in human history.

In their narrative art, Greek painters and sculptors focused on the most momentous events in mankind's past from their religious viewpoint. They tell the story of the ancient paradise, the story of the line of Kain (Cain) disappearing into the earth during the Flood, and most dramatically and boastfully, the story of the reestablishment and dominance of the serpent's system (the way of Kain) after the Flood. While the viewpoints of Genesis and Greek artists are opposite, the recounted events and characters match each other in convincing detail.

Two of the most important qualities of ancient Greek art are rationalism and realism, and what their art depicts is both rational (it makes sense) and real (it is history).

Massive amounts of religious and historical information survive from the ancient Greek world. The ancient artists had all of that available to them and more. They learned their history from the previous generations' artists; and, distilling the information they received from them and from the ancient poets, they presented what they knew in the simplest possible images. As we shall see, sometimes they competed with each other to develop the clearest or most creative way to convey an historical fact or religious idea.

The Greek gods look exactly like people because, with rare exceptions, that is who they represent. In Plato's Dialogue, *Euthydemus*, Sokrates referred to Zeus, Apollo and Athena as his "lords and ancestors." Another witness to this obvious truth is the life of the great hero, Herakles. À la "George Washington slept here," scores of Greek towns claimed that Herakles had performed some kind of great feat (often one of his twelve labors) within or near their boundaries. Herakles was a real man.

On the vase-painting, opposite top, Athena picks up the hero Herakles in her chariot at his death, and takes him to immortality on Mount Olympus. Who does he join there, space aliens? Of course not. He joins his ancestors, the Olympian family. If it looks like a human, talks like a human, and acts like a human, it must be a human. This is the key to understanding Greek art.

The Greeks claimed their descent from an original brother-sister/husband-wife pair named Zeus and Hera. Zeus and Hera are the Greek versions of Adam and Eve. The Greeks referred to Zeus as the father of gods (ancestors) and men, and to Hera as the mother of all living. Their poets and playwrights traced this first couple to an ancient paradise called the Garden of the Hesperides, and always depicted it with a serpent-entwined apple tree, as in the vase-scene from 420 BC, opposite. The names of the female figures written on the vase—Hygeia (Health), Chrysothemis (Golden Order), Asterope (Star Face), and Lipara (Shining Skin)—describe what the garden is like. It's a land of soft starlight, gold for the taking, perfect health, and wondrous beauty.

You have probably heard at one time or another about Eve eating the apple. The Hebrew word for fruit in Chapter 3 of Genesis is a general term. The idea that Adam and Eve took a bite of an apple comes to us from the Greek tradition.

Zeus and Hera had two surviving sons that had offspring. Their eldest, Hephaistos, corresponds to Adam's and Eve's eldest, Kain (Cain); Zeus' and Hera's youngest, Ares, corresponds to Seth.

Greek artists and intellectuals knew all about Kain having killed Abel. They depicted that event in a series of four metopes (square sculpted scenes) on the south side of the Parthenon (See Chapter 6 of *The Parthenon Code*). Opposite, we see a drawing of the metope by Jacques Carrey from 1674, that depicts the murder itself.

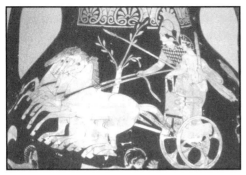

Athena Takes Herakles to Olympus

Kain Kills Abel

The Greek Version of Paradise—The Garden of the Hesperides

The Greek gods were as human as the ancestors we revere. Why does Abe Lincoln appear on the penny and on the five-dollar bill? Because of who he was and what he did. Why did Athena, Herakles, and Hermes appear on Greek coins? Because of who they were and what they did. Why do we build monuments to our presidents such as Mount Rushmore and the Lincoln and Jefferson Memorials? For the same reason Greeks built monuments (temples) to Zeus, Hera, Artemis and Athena. For both sets of revered humans, it is about who they were and what they did.

If you hadn't already noticed, *our* memorial architecture in which *our* ancestral heroes in America are exalted is based on the ancient Greek temple architecture in which *their* ancestral heroes were exalted.

And coming is it that humanity starts to be multitudinous on the surface of the ground, and daughters are born to them. And seeing are the sons of the Elohim [the spiritual line of Seth] the daughters of the human [the soulish line of Kain], that they are good, and taking are they for themselves wives of all whom they choose.

Genesis 6:1-2

When you read the Genesis account of the Flood, it is easy to assume that it wiped out the entire line of Kain, and that only eight people, all from the line of Seth, survived. At one time, I erroneously assumed that myself. The Greeks knew better. They knew about the woman from the line of Kain on board the ark. We'll get to her shortly, but first we need to look at one way in which the Greeks often differentiated between the line of Seth and the line of Kain in their art.

Greek artists, embracing the way of Kain themselves, depicted the line of Kain as civilized and noble humans. They depicted what they considered to be the less civilized line of Seth as half-men/half-horses they called Kentaurs. Chapter 6 of Genesis describes how, before the Flood, all humanity, save Noah and his family, went the way of Kain. What happened? The men of the line of Seth took their women from the line of Kain (See Genesis quote, above), and these women, retaining their fervor for the way of Kain, corrupted their husbands' outlook. Only Noah and his family continued to worship Yahweh, the Creator.

The Greeks depicted the Seth-men seizing the Kain-women on the south side of the Parthenon (opposite, top and center), and on the temple of Apollo at Bassai (opposite, bottom). In both sets of sculptures, the Kain-women seek refuge around their idol in the midst of the chaos. The Kain-women depicted on the Parthenon express their devotion to it less dramatically than those depicted on the temple of Apollo at Bassai. The woman to whom they resort is most likely Eve, whom the Greeks later worshipped as Hera, "the mother of all." That undying devotion of the Kain-women to their original serpent-friendly female ancestor is what undermined the line of Seth's faithfulness to Yahweh.

Because of the influence of the Kain-women, all families save that of Noah, ceased looking in a spiritual way toward their Creator, and instead embraced a soulish orientation, living in accord with their senses and exalting their own humanity as supreme. Then came the Flood.

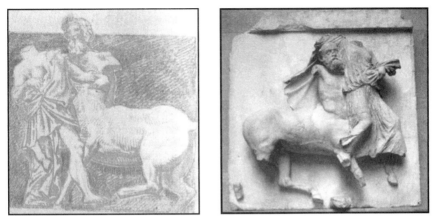

Seth-men (Kentaurs) Seize Kain-women before the Flood

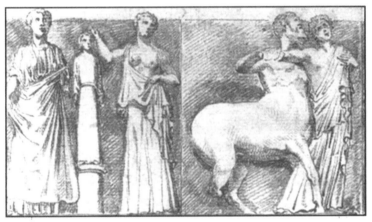

Besieged Kain-women Take Refuge with Their Goddess I

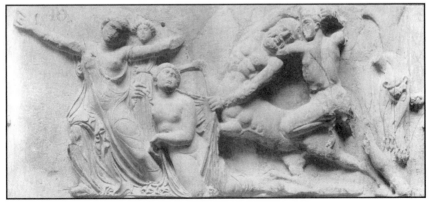

Besieged Kain-women Take Refuge with Their Goddess II

The worldwide Flood that wiped out the line of Kain (save for one woman whom we're getting closer to identifying) was part of the Greeks' collective cultural memory. They depicted it quite often as Kentaurs pounding a man named Kaineus into the earth. The Kentaurs represented the line of Seth which survived the Flood.

Note that on the partially damaged vase from about 550 BC (opposite top), the painter has written the name KAINEUS. The word for the eldest son of Adam and Eve as it appears in the Greek Scriptures is KAIN. KAINEUS does not represent just one man. EUS at the end of a noun means "stemming from or pertaining to" that particular noun. Thus KAINEUS is the human representation of the entire line of KAIN.

The Greeks referred to Kaineus, the line of Kain, as invulnerable, and since they wholeheartedly re-embraced the way of Kain after the Flood, the line of Kain's invulnerability was to them a fact. Greek artists often celebrated the reemergence of the line of Kain after the Flood, as on the vase-scene, opposite. It summarizes the story of how Athena took the sperm, or seed, of Hephaistos (the deified Kain, pictured to our left of the child), and placed it into the earth. Out of that same Earth into which Kaineus had been pounded, the line of Hephaistos, or Kain, reemerged in the form of a special child known as Erichthonios, "the Earth-born One."

Who is Athena? This vase-scene and many others tell us that she is nurturer and protectress of the line of Kain. In *The Parthenon Code*, I identify Athena as the reborn serpent-friendly Eve, and so she is. Just as the original Eve, deified by the Greeks as Hera, welcomed the serpent's enlightenment in the garden, so did Athena welcome it after the Flood. While I connect Zeus to Adam, Hera to Eve, Hephaistos to Kain, Ares to Seth, Nereus to Noah, Chiron to Ham, Hermes to Cush, and Herakles to Nimrod, I could not pin Athena to any specific character. But remember, Sokrates referred to Athena as one of his ancestors. What human, then, does Athena represent?

I am happy to say that after collaboration with David Allen Deal, author of *Noah's Ark: The Evidence*, I can tell you specifically who she is. She welcomes the child from the line of Kain. She must be part of the line of Kain herself, and she must have come through the Flood on the ark. The evidence strongly suggests that Noah's son, Ham, brought a wife from the line of Kain with him through the Flood.

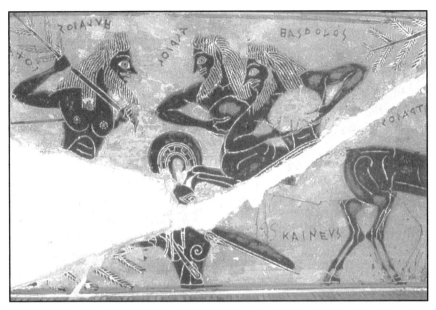

KAINEUS (the Line of Kain) Disappears into the Earth during the Flood at the Hands of the Seth-men (Kentaurs)

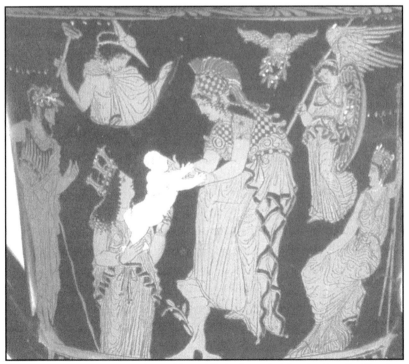

Athena Welcomes the Reborn Line of Kain from the Earth after the Flood

Just one step remains before we name the woman from the line of Kain who came through the Flood as Ham's wife. We need to examine the most unusual way in which the Greeks depicted Noah's son, Ham. Because he was part of the line of Seth, they depicted him as a Kentaur, a very distinguished-looking Kentaur.

In the sculptures and vase-paintings we've seen so far showing Kentaurs, and on the depictions, opposite top, we note that their bottom front half is that of a horse. Kentaurs are almost always depicted like that. The image emphasizes their wildness and lack of refinement compared to the line of Kain which, before the Flood, established the first city (Genesis 4:17), and after the Flood, developed the foundation of human culture as we know it. Kentaurs (Seth-men), from the standpoint of the line of Kain, were repulsive rubes, brutal boors, and uncivilized beasts.

One Kentaur, Chiron, stood out from all the rest. And that one Kentaur, that one man from the line of Seth depicted in a radically different way from all the others, was Ham. Though he was a son of Noah, Ham looked with favor upon the way of Kain because he was married to a Kain-woman. Greek artists knew this and depicted him accordingly. They called him Chiron because it means "Hand" in Greek, and suggests that he gave an early helping hand to the development of Zeus-religion.

Look how the artists humanized Chiron in the vase-depictions opposite. He is not pictured as a crude enemy, but as a civilized friend. His front legs are not equine, but human. If you stood directly in front of him, you wouldn't even know that he was a Kentaur. Chiron/Ham brought much knowledge including the knowledge of medicine through the Flood. In the *Iliad*, Homer referred to Chiron as the "most righteous of the Kentaurs." Edward Tripp writes of Chiron, "He differed from other Kentaurs in his nature. They were barbaric and unrestrained in their habits. Chiron was one of the wisest and most learned of living beings. As a result, several of the greatest of the Greeks were sent as children to his cave on Mount Pelion to be reared by him. Among these pupils were Jason, Asclepius, Actaeon, and Achilles." The legend that he taught these men probably involves the compressing of time. It is doubtful that Chiron/Ham lived long enough to tutor all of these heroes. They were able to learn because of him; the knowledge he brought through the Flood enabled other men to teach these great Greek heroes.

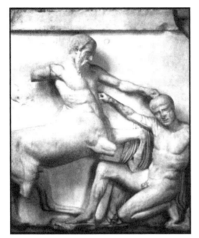 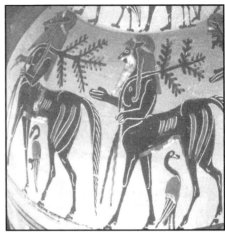

Typical Images of Kentaurs in Greek Art

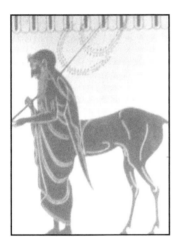

Left, Right, and Below: the Singular Image of the Kentaur Chiron/Ham on Vases

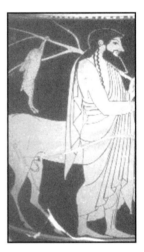

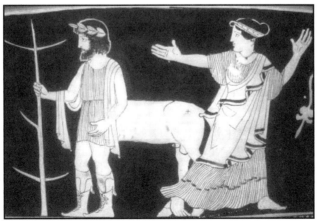

Who was the wife of Ham/Chiron? The answer, as we might expect, is found in Genesis. Genesis 4:17-22 traces the generations of the line of Kain. The last person mentioned is Naamah, the sister of Tubal-kain. No women in the line of Seth are named before the Flood. So why would Naamah be mentioned unless she was a woman of great significance?

Naamah was a woman of great significance, indeed. Noah's son, Ham, married her and brought her through the Flood. And just as before the Flood, the other women from the line of Kain who had been taken as wives by the Seth-men ultimately remained true to the way of Kain, so did Naamah after the Flood, only ten-fold.

Now let's go to a most revealing 782-page book by Anne Baring and Jules Cashford called *The Myth of the Goddess*. The authors do not treat Genesis as a valid historical account of mankind's origins. In spite of that, if I were to review it, I'd give it five stars because it is very comprehensive, well-written, and full of ancient images—a goldmine of information. The authors trace the goddesses of the ancient Near-eastern and Mediterranean world to a single original goddess named Nammu—close enough to the pronunciation of Naamah, sister of Tubal-kain, to merit our closest attention.

"The earliest Sumerian creation myth," they write, "tells the story of Nammu, Goddess of the Primordial Waters, who brought forth the cosmic mountain, An-Ki, Heaven and Earth." The Primordial Waters are the Flood waters; the cosmic mountain, where the ark landed. The peaks of the mountains of Ararat often disappeared into the clouds, so it seemed that Naamah/Nammu had come from above, from heaven to earth.

I would add and change some words in Baring's and Cashford's book, and also change the title from *The Myth of the Goddess* to *The Memory of the Adored Woman*, because that's what it is really all about. The authors can't see this simple truth, and so remain puzzled as to why ancient goddesses so dominated ancient Mediterranean cultures: Ishtar, Inanna, Asherah, Isis, Demeter, Artemis, Athena—all, in their own scholarly judgment, derived from Nammu. Baring and Cashford confess that they do not know how the goddess image first arose, "whether from dreaming sleep or from waking vision." But it was not a dream or a vision that led to the veneration of the goddess throughout the ancient world, but rather a real woman named Naamah descended directly from

Kain. The majority of humanity adored her because she brought the way of Kain through the Flood, and through her offspring, Cush/Hermes and Nimrod/Herakles, reestablished its dominance.

According to Baring and Cashford, the ancients referred to Naamu as "the great serpent goddess of the abyss." The abyss is the great deep—the Flood waters that covered the earth. The line of Kain welcomed the serpent's enlightenment, and so she was "the great serpent goddess."

Chapter 19 of the Book of Acts sheds some light on how the ancients understood their goddesses. In Ephesus, the silversmith, Demetrius, earned his living making images of Artemis and her temple. He felt threatened when the apostle Paul inferred that Artemis wasn't really a goddess, but just a dumb idol. Demetrius knew full-well that goddesses of the Near East and Mediterranean had different names in various languages, and yet he said of Artemis that "the whole province of Asia and the inhabited earth is revering [her]." His statement indicates that he understood that many goddesses with different names in different nations exalted the very same woman: a very, very important woman.

The ancient poet Homer referred to Artemis as the "Mistress of Wild Animals." This makes no sense unless we connect her to Naamah/Nammu, wife of Ham, on board the ark with all those wild animals for about a year. Most of mankind gave *her* credit, not Noah, for bringing the animals through the Flood.

Most of the significant ancient goddesses were linked to the Flood in some way, beginning with the one whom they represented, Nammu. Baring and Cashford: "The images of water and sea, the unfathomable abyss of the Deep, return us to Nammu, the Sumerian goddess whose ideogram was the sea . . ." Baring and Cashford again: "Asherah [a Caananite goddess] was called 'the Lady of the Sea,' which links her to the Sumerian Nammu, and to the Egyptian Isis, 'born in all wetness.'" Those descriptions of the great goddess evoke the memory of the Flood.

According to Baring and Cashford, in both the Babylonian and Sumerian stories, Inanna and Ishtar, derivative goddesses of Naamah/Nammu, lament the destruction of their people in the Flood. In the *Epic of Gilgamesh*, Ishtar prepares a post-Flood offering similar to the one Noah prepared for Yahweh in Genesis 8:20. There is one huge difference: Ishtar says, "Let all the gods gather round the sacrifice, except

Enlil (Yahweh*). He shall not approach this offering, for without reflection he brought the Flood; he consigned my people to destruction." Ishtar is Naamah. Her "people" are the people of the line of Kain left behind to drown in the Flood. They include her closest relatives: her brother Tubalkain, her mother Zillah, her father Lamech, and her half-brothers Jubal and Jabal (Genesis 4:19-22). Now with Yahweh excluded as an object of worship, the most important of her ancestors, as well as she, become gods. As the one who came through the Flood—the link to the pre-Flood world—she becomes the foremost of the post-Flood gods.

According to Baring and Cashford, "Another version [of the ancient texts] says that Ishtar placed her many-jeweled necklace, which encircled her neck like the rainbow, in the sky to prevent Enlil [Yahweh] receiving the sacrificial offerings on earth 'since rashly he caused the flood-storm, and handed over my people to destruction.'" Ishtar, another name for Naamah/Naamu, not only keeps Yahweh from being worshipped, but takes the rainbow that Yahweh sent as a sign (Genesis 9:12-17), as *her* sign of peace between herself and mankind. Zeus-religion also usurped Yahweh's sign of the rainbow deifying it as the goddess Iris (Rainbow), making her a messenger of Zeus and Hera.

In addition to worshipping Naamah/Nammu as Artemis, "Mistress of Wild Animals," and as Athena, Goddess of Wisdom, War, and Crafts, the Greeks also worshipped Naamah/Nammu as Demeter, goddess of vegetation, because she was perceived as the one who brought the seeds through the Flood.

Let's put into perspective the emergence of the ancient goddesses after the Flood as personas of the woman Naamah. Today, throughout the civilized world, we see many sculpted and painted images of Jesus Christ. These images exist because of a real Man who lived 2,000 years ago. In 400 BC, throughout the then-civilized world, we find sculpted and painted images of Athena, Artemis, Isis, Demeter, Asherah, Ishtar, and Inanna—all personas, or different aspects, of the real woman Naamah/Nammu who brought the way of Kain through the Flood about 2,000 years prior to that time. (According to the scriptural record, the Flood occurred in 2421 BC). The ancient images of the goddess are no more the

*Baring and Cashford say Enlil is Yahweh.

products of dreaming sleep or waking vision (as Baring and Cashford suggest) than are the images of Christ today. Images of Christ today represent a real historical Man. Ancient images of the goddess represent a real historical woman—Naamah/Nammu, sister of Tubal-kain and wife of Noah's son, Ham.

Naamah and Christ are the two most influential people of the post-Flood age. The ancient world revered and worshipped Naamah/Nammu as the woman who brought the serpent's enlightenment through the Flood, rejuvenating the way of her ancestor, Kain. Believers worship Christ as the Son of God, the One Who, in His very Person, brought God's light into a world ruled by the way of Kain.

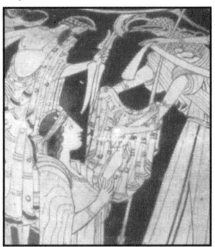

In the Presence of Zeus, Earth Presents Erichthonios to Athena

Naamah was born before this age began. That means the two most important *births* of this age are those of Erichthonios, who represents the reborn line of Kain after the Flood, and Jesus Christ, the Son of God.

Gilgamesh, the Akkadian version of Nimrod/Herakles was said to be "king of Uruk" or "Erech," which sounds the same as the Erich in Erich-thonios. It's most likely that the Greeks are celebrating the birth of Herakles/Nimrod, king of Erech, and son of Hermes/Cush. Many different gods (ancestors) appear in vase-scenes depicting the birth of this special child, but never Herakles/Nimrod as a grown man.

Just about everyone, atheists and agnostics included, recognize the bottom scene as the birth of Christ. But how many people grasp the profound meaning of the birth depicted above it?

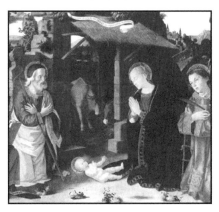

The Birth of Christ

If, in the Greek religious system, Demeter, Artemis, and Athena are all personas or aspects of the real woman, Naamah/Nammu, why is Athena the dominant one? Why is she the favored daughter of Zeus? It is because Athena represents the most essential aspect of Naamah—dedication and submission to the ancient serpent and its wisdom. That is the heart and soul of Zeus-religion and the way of Kain. As Demeter, Naamah brought the seeds through the Flood; as Artemis, she brought the wild animals through it. Both were very important, but it is the exaltation of the serpent's wisdom that is the distinguishing, defining, and crucial achievement of Naamah. That is why Greek artists almost always depicted Athena with a serpent or serpents, as in the images below.

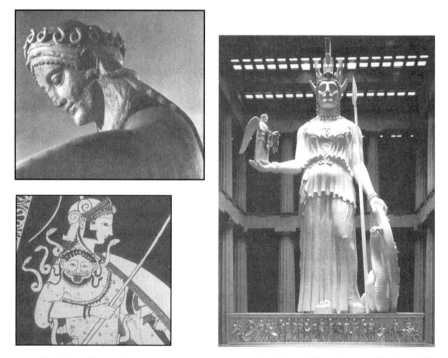

Greek artists made certain there was no mistaking Athena's association with the ancient serpent and its wisdom. Above left, from her pre-Parthenon temple on the Akropolis of Athens, she wears a crown of serpents. In the vase-depiction, below left, she wears the Gorgon Medusa, the head of serpents, on her aegis, or goatskin. (Baring and Cashford point out that a gorgon's head is found on Artemis as well as in Demeter's shrines, but that it was only later identified exclusively with Athena). And as part of her reconstructed idol-image in the Parthenon in Nashville, the ancient serpent rises up next to her as a friend. She holds Nike in her right hand: her friendship with the serpent has led her to Victory.

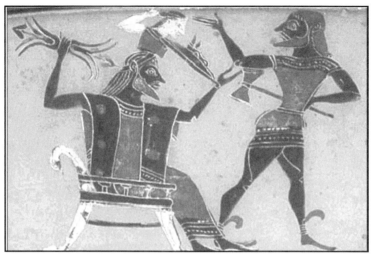

The "Birth" of Athena/Naamah

On the vase-scene above from about 560 BC, we see the birth of Athena depicted. Zeus, "the father of gods and men," seated on his throne, is the Greek version of the serpent-friendly Adam. Hephaistos, god of the forge, is his eldest son—the Greek version of Adam's and Eve's eldest son, Kain. Athena represents Naamah, sister of Tubal-kain and wife of Ham, who brought the way of Kain through the Flood.

According to the "myth," Zeus swallowed Metis, or Wisdom, and then some time later, Athena emerged full-grown and fully-armed from his head. What wisdom did Zeus swallow that ultimately led to its embodiment in the goddess? The wisdom from the pre-Flood world. By swallowing the wisdom from the line of Kain, he protected it so that he might give it new life after the Flood in the person of Athena/Naamah. Athena is pictured as being full-grown because after the Flood, when Naamah began to exert her influence on behalf of the way of Kain, she *was* full-grown. She is fully-armed because she initiated and encouraged the post-Deluge battle to restore the rule of the serpent's enlightenment.

The "myth" tells us what happened to humanity's amassed knowledge stemming from the serpent's enlightenment in the ancient garden, seemingly lost in the Flood. Zeus preserved it and brought it back into being through Athena. On the vase, Hephaistos/Kain gestures as if to say, "She is one of our own, destined for greatness." This is not myth, but a near-perfect depiction of what really happened after Noah's Flood.

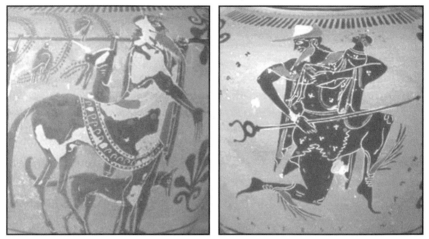

Hermes, Carrying Herakles, Flees from the Authority of Chiron

In the illustrated genealogy, opposite, we see how Noah's offspring turned to the way of Kain. Above, a vase-painter has told this story as succinctly as possible. On one side, Chiron/Ham gestures with his right hand as if to say to his son, Hermes/Cush, "Hey, what's wrong? Where are you going?" On the other side, Hermes/Cush runs from Chiron/Ham with his own son, Herakles/Nimrod, in his arms. Hermes and Herakles are named on the vase. Hermes/Cush runs away from the authority of Chiron/Ham and his father Nereus/Noah.

Chiron functioned as an enabler for the development of Zeus-religion but did not fully embrace it himself. If he had fully embraced the religious outlook of his Kainish wife, Naamah, Hermes would not be pictured as fleeing from him with Herakles. While Chiron compromised with the line of Kain, becoming partly "humanized," Hermes and Herakles became fully humanized, embracing Zeus-religion, the enlightenment of the serpent, the way of Kain, and the exaltation of humanity as the measure of all things. Further, in Greek "myth," key ancestors in the way of Kain were said to have Zeus (the serpent-friendly Adam) as their spiritual father. Hermes/Cush, Herakles/Nimrod, and Athena/Naamah were all spiritual children of Zeus. In Greek "myth," Chiron/Ham was not known as a spiritual child of Zeus.

Where is Hermes running? To his mother's side of the family. Mankind recognized the all-pervasive influence of Naamah, exalting her different personas as goddesses throughout the ancient world.

NEREUS/NOAH

A prophet of Yahweh in the line of Seth who brought mankind through the Flood.

CHIRON/HAM

The "good" Kentaur (Seth-man) because he brought his wife, Naamah, of the line of Kain, through the Flood.

HERMES/CUSH

Born on his mother's side from the line of Kain, turned from Noah and Yahweh, embraced and spread Zeus-religion.

HERAKLES/NIMROD

As Naamah's grandson, led the armed rebellion against Noah and his Yahweh-believing children.

Here is how the renunciation of Noah and his God proceeded from his son, Ham (who brought Naamah through the Flood as his wife) through his son, Cush, to his son, Nimrod. Or as the Greeks remembered them, from Chiron through Hermes to Herakles. The most influential person in this great spiritual transformation, Ham's wife Naamah, is not shown here. Some of her images and different names in the ancient world appear on the following two pages.

Astarte (Semitic)

Hathor (Egypt)

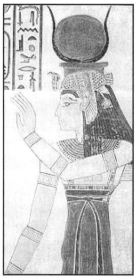

**ASPECTS OR
PERSONAS OF
THE WOMAN
NAAMAH/NAMMU**

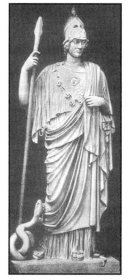

Isis (Egypt)

Athena (Greece)

Demeter (Greece)

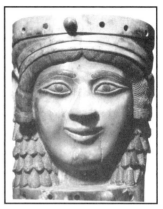

Ishtar (Babylon)

Inanna (Sumer)

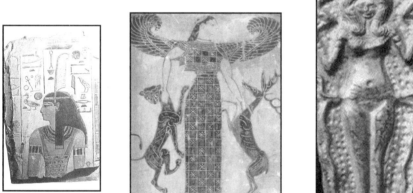

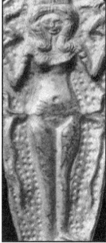

Maat (Egypt)

Artemis (Greece)

Asherah (Canaan)

Naamah must have lived for a very long time to have become so adored throughout the Mediterranean and Near-eastern world. Opposite top left, we see her as the Semitic Astarte standing on skulls. Many die, while the great one lives on.

Athena's name associated her with long life. In the most ancient Greek writing (Linear B), the name of the goddess first appears as *Athana*. The word *thanatos* in ancient Greek means death. A-thanatos signifies deathlessness. Athana is the shortened form of Athanatos meaning the deathless one.

According to Genesis, Noah lived for 350 years after the Flood. According to the Greek tradition, he lived long enough to sire fifty daughters. Noah's son, Shem, lived for 501 years. Naamah came through the Flood with these men, and probably lived 400 to 500 years herself.

Over several generations, Naamah, with the help of her offspring, Cush/Hermes and Nimrod/Herakles, won the adoration of the majority of humanity, taking credit for bringing civilization through the Flood. In the following section, as we look at images of Noah in ancient Greek art, we ought to see him depicted as being superseded by her, by her son, Hermes/Cush, and especially by her heroic warrior grandson, Herakles/Nimrod. Let's see what we actually find.

SECTION II

Noah's Place in Ancient Greek Art

And speaking is Yahweh Elohim to Noah, saying, "Fare forth from the ark, you, and your wife, and your sons, and your sons' wives with you. And every living thing which is with you of all flesh, of flyer, and of beast, and of every moving animal moving on the earth, bring forth with you. They also are to roam in the earth, and to be fruitful and increase on the earth."

And forth is faring Noah, and his sons, and his wife, and his sons' wives with him. And every living thing and every beast, and every flyer, and every moving animal moving on the earth, by their families they fare forth from the ark.

And building is Noah an altar to Yahweh Elohim, and taking is he of every clean beast, and of every clean flyer, and is offering up ascent offerings on the altar.

And smelling is Yahweh Elohim a restful smell. And saying is Yahweh Elohim to His heart, "Not any more will I slight further the ground for the sake of humanity, for the form of the human heart is evil from its youth. Neither again will I smite further all living flesh, as I have done. In the future, all the days of the earth, seedtime and harvest, and cold and warmth, and summer and winter, and day and night shall not cease."

And blessing is the Elohim Noah and his sons. And saying is He to them, "Be fruitful and increase and fill the earth and subdue it."

Genesis 8:15 - 9:1

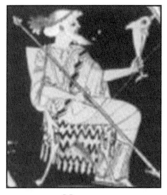

Nereus.
British Museum, E73

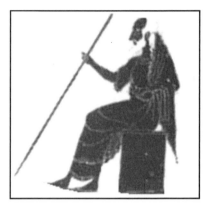

Nereus. Wadsworth
Atheneum, Hartford, CT, 1961.8

Nereus. Paris, Musée
du Louvre, G428

Nereus. Harvard Univeristy Art
Museum, 1927.150

Greek artists knew that immediately after the Flood, Noah ruled. They depicted him quite often on vases. They called him Nereus, the "Wet One." He is sometimes shown with the bottom half of a fish signifying that he came through the Flood waters. Sometimes artists portrayed him holding a fish, a kind of shorthand reminder that he came through the Flood. Nereus/Noah is almost always shown with his scepter, a symbol of rule. As the rebellion against him proceeded, a new scepter appeared, held by his grandson Hermes/Cush, a scepter entwined with serpents and signifying the rule of the ancient serpent from Eden.

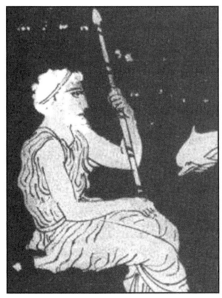

Nereus.
Berlin, Antikensammlung, 3244

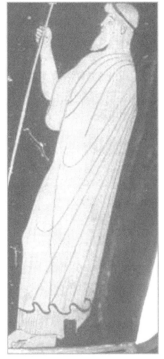

Nereus. Yale University
Art Gallery, 1985.4.1

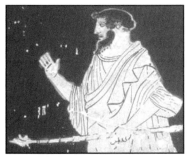

Nereus. Martin von Wagner
Museum, Würzburg, L 540

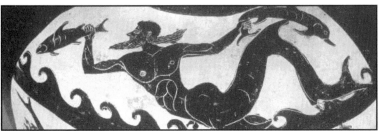

Nereus. Toledo Museum of Art, 1982.134

As indicated beneath each vase, ancient Greek images of Noah appear in Museums throughout the world. The curators remain oblivious to the true identity of this figure who brought humanity through the Flood.

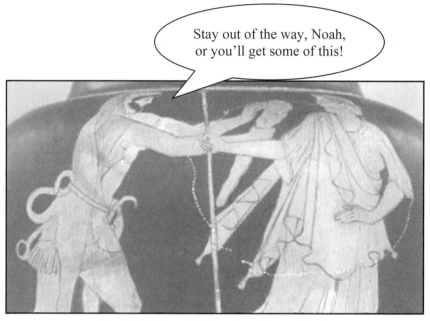

Herakles/Nimrod Threatens Nereus/Noah

Many of the extant vases featuring Nereus/Noah show him being disempowered in some way. In almost all cases, his authority is being usurped, and yet he never resists. As we shall see presently, sometimes Nereus/Noah receives the news of his disempowerment indirectly from his daughters. Sometimes the artists picture Herakles/Nimrod taking the authority of Nereus/Noah directly from him, as on the vase-scene, above. Herakles chases after Nereus, pointing to his club, a symbol of his strength. Nereus is backing up, reacting to the aggressive body language of Herakles. The artist's message is simple: Herakles is telling Nereus to back off and stay out of the way.

Note that the serpent coils itself into Herakles' belt. This tells us that the serpent is intricately related to this takeover. The weaponless Nereus/Noah does not fight back; he always remains passive, stoic even, in the face of this great religious transformation.

On the vase-scene, opposite top, Herakles shoves Nereus/Noah out of the way almost as if he were a useless and embarrassing piece of furniture that had to be hidden from sight. Note that Nereus is not fighting Herakles, but rather raising his hands as if to say, "Hey, what do you think you're doing?"

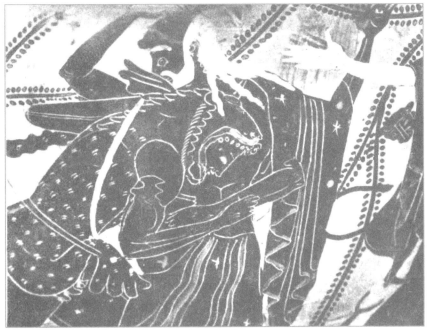

Herakles/Nimrod Pushes an Unresisting Nereus/Noah out of the Way

Below, another vase-artist depicts the same idea in a different way. The nude Herakles, brandishing his club in his right hand, comes astride Nereus and grasps his neck with his left hand. He is bringing the momentum of Nereus to a halt, and by extension, he is bringing the rule of Nereus/Noah to an end, replacing it with Zeus-religion. Behind Nereus, Poseidon, a "brother" of Zeus, steps up and replaces the "Wet One" as god of the sea. Herakles may as well be saying, "Hold it, Nereus, your reign is over. Poseidon and Zeus-religion rule now."

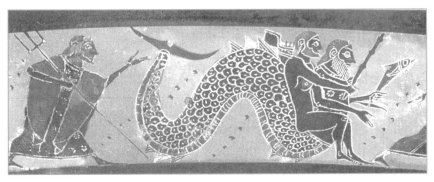

Herakles Brings Noah's Rule to a Halt as Poseidon Advances

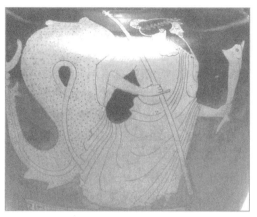

Triton—the Young Nereus/Noah

The ancient artists used another way to express the idea that Nereus/ Noah lost his power to the Greek religious system. They created a young Nereus, a half-man/half-fish they called Triton (vase-scene, above) who represented Nereus himself at the height of his powers. Basically, the artists created two different images for Nereus: one which represented his authority, and the other which represented the helpless and usurped old man himself. Using these two related images, the artists could picture the authority of Nereus/Noah being wrestled away without showing any harm coming to the one their poets called the "Old Man of the Sea."

Opposite, we see a vase-depiction from about 520 BC of Herakles coming to grips with Noah's authority represented by the fish-tailed Triton. If the artists had wanted to show Herakles killing a monster, they would have made it very obvious as they did on many other vases where killing was part of the action. But on these vases and many others, the artists make Herakles' grip on Triton the focal point of the encounter. The artists invented Triton as a symbol with which Herakles was able to grapple. He is wrestling away Triton—Noah's authority and power— seizing them for the developing Greek religious system. After the Flood, humanity ceased fearing the God of Nereus/Noah, and instead began to boast in the great hero, Herakles, and worship the gods of Zeus-religion.

On this vase, one of the daughters of Nereus sees what is happening and gestures to her father as if to say, "What's happening, Dad? Aren't you going to do something about this?" The answer is no. Nereus will do nothing. According to Genesis, Yahweh actually spoke to Noah, then

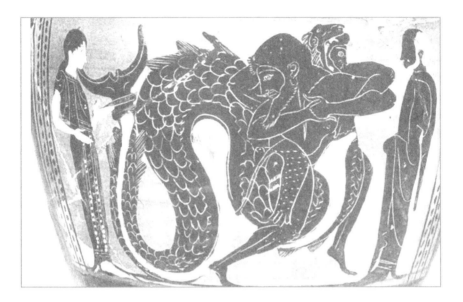

guided him for a hundred years in the building of the ark, and then took him and his family through the Flood. Noah had a profound understanding of what was happening, and he knew that the One "Who is operating all in accord with the counsel of His will" (Ephesians 1:11) had a purpose in it. The Greek artists faithfully recorded the historical facts that Nereus/Noah was never harmed and that he never physically resisted the takeover of Zeus-religion.

In the blow-up of part of the vase, below, we see Herakles stare down Noah. Herakles wears his lion-head, a symbol of earthly power.

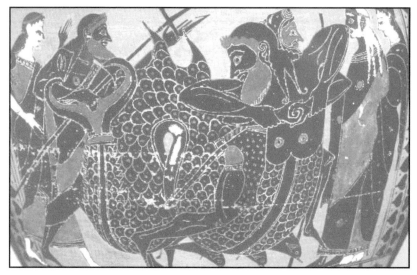

Poseidon Poised to Take Noah's Authority, Wrestled Away by Herakles

The vase-depiction of Herakles and Triton, above, tells the story in more detail. Herakles harms or kills many of his opponents, but never Nereus or Triton (the younger Nereus). Here, he wrestles with Triton, grabbing him from behind. Notice the interlocking hands of Herakles. He is coming to grips with Noah's legacy. On the vase, he is wrestling it away from the Old Man of the Sea who stands to the right leaning on his staff with his wife, Doris, disconsolate at the turn of events he will do nothing to prevent. On the left, behind Triton's tail, stand Poseidon (with trident) and his wife, Amphitrite, a daughter of Nereus and Doris. Poseidon and Amphitrite bend toward the action with their arms upraised, in gestures that indicate their involvement with its outcome.

What a magnificent painting! Herakles is wrestling away Nereus' authority and his association with the power of the sea and giving both to Poseidon, a brother of Zeus. Poseidon becomes god of the sea and its power. Nereus still has a place in Greek history, but as a believer in the Creator God, Yahweh, no place on Mount Olympus.

Nereus and His Wife, Doris

Herakles Seizes Noah's Authority, Elbowing Him out of the Way

On the above vase, the scene is familiar to us. Herakles wrestles away Triton (the authority of Nereus/Noah) as Nereus and one of his daughters look on. As we see in the blow-up, below, the artist makes a point to obscure part of the face of Nereus. He is being elbowed out of the way. The belief system of Noah contradicts the reemerging way of Kain: the Old Man of the Sea and his God must be pushed aside.

Enlarged Section of above Vase

On this Attic black-figure cup from about 520 BC, below and opposite, the artist takes the seizure of power from Nereus/Noah a step further. On one side of the cup, he shows Herakles wrestling with Triton. We now understand what the Greeks understood from such an image: this depicts the power of the Greek religious system coming to grips with the authority of Noah and wrestling it away from him. But what happens once that authority is wrestled away? The artist tells us exactly what happened on the other side of the cup.

There we find Herakles chatting with Dionysos, the god of wine and revelry. Nereus/Noah was a spiritual man. Dionysos represents the soulish man, the man who lives according to his senses. In the center of the inside of the cup, below, the artist has painted the head of the Gorgon Medusa—the head of serpents. Around the Gorgon head, six Greeks relax at a drinking party. Humanity is free from the God of Noah, free to follow its soulish and sensual urges.

On the cup, Dionysos holds a *kantharos* in his hand. Greek artists used this drinking cup as their basic symbol of transformation. The artist's painting celebrates humanity's change in orientation from the spiritual to the soulish—from a God-centered system of belief to a human-centered system. Who are the most important figures in a human-centered system? The great humans of history: Kain (Hephaistos), Cush (Hermes), Nimrod (Herakles), Naamah (Athena), and of course the first man and the first woman whom the Greeks deified as Zeus and Hera.

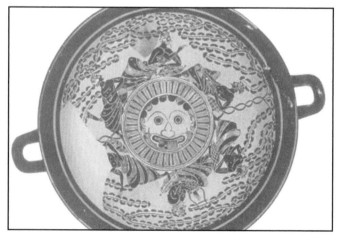

Cup Interior: Gorgon Medusa and Revelers

Side A: Herakles Wrestles Away Noah's Authority, Symbolized by Triton

Side B: Herakles Chats with Dionysos, Soulish God of Revelry and Wine

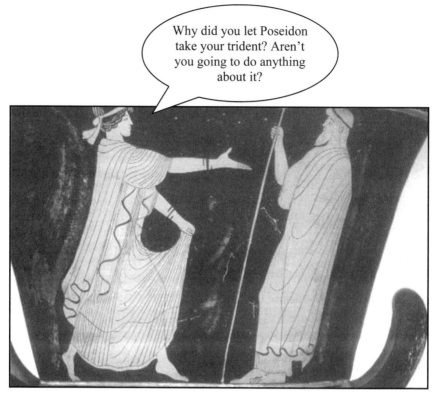

Nereus' Daughter Demands to Know What He Will Do about Poseidon's Takeover

The two sides of the Attic red-figure storage jar pictured above and opposite top affirm that Nereus has been replaced. On one side, a daughter of Nereus runs to him. From the sense of urgency in her body language and her extended, pleading arm, we see that she is insisting that he take action in regard to something that has occurred. What the daughter of Nereus/Noah is worried about is pictured on the other side. There, Nike, the winged goddess of Victory, pours a drink offering to the newly-enthroned Poseidon, the "brother" of Zeus. A new religious system has taken over, and the daughter of Noah wants to know what he is going to do about this usurpation.

On the red-figure vase-depiction opposite bottom, Nike stands in the center between two folding stools, where Amphitrite and Poseidon sit facing each other. Poseidon has taken Amphitrite as his wife. In his left hand, Poseidon holds the trident, a symbol that used to belong to Nereus.

As a daughter of Nereus, Amphitrite used to belong to him. As the

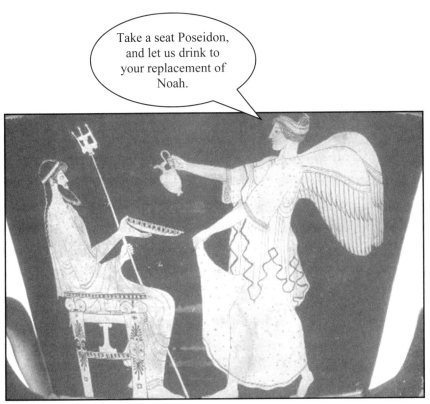

Nike Celebrates Poseidon's Takeover with a Drink Offering

wife of Poseidon, she now belongs to the new god of the sea, and has become part of Zeus-religion. This is the victory they are celebrating. By pouring out the wine, Nike is ritually sealing their victory over Nereus/ Noah, and affirming their place in the Greek pantheon.

The average Greek looking at this scene would have known that it was Herakles who made this celebration possible, that he was the one who had forced Nereus/Noah out of the picture.

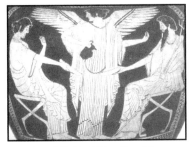

Amphitrite, Nike, Poseidon

Nereus, Original Trident Owner

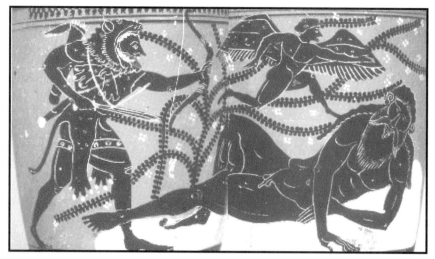

Hypnos Puts the Giant Alkyoneus to Sleep as Herakles Approaches

In one artistic tradition, Greek artists depicted the Yahweh-believing sons of Noah as Giants over whom they celebrated their great victory.

Above, from about 510 BC, Hypnos, the god of sleep, has put the Giant, Alkyoneus, to sleep as Herakles approaches. Herakles acted so aggressively and so decisively that the Giants hardly knew what happened. Many of the Yahweh-believing sons of Noah didn't pay attention to the momentous spiritual changes; they remained oblivious, asleep. On the drinking cup below from about 525 BC, Herakles and Hermes offer gestures of congratulations to each other. They have caught a Giant unawares. They have put the serpent's system of worship and sacrifice in the place of Noah's. The language of Greek artists is universal.

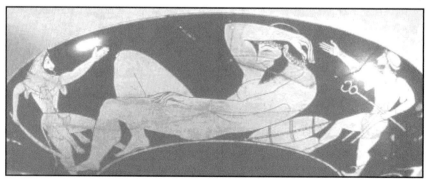

Herakles and Hermes Gesture to Each Other as They Find a Giant Asleep.

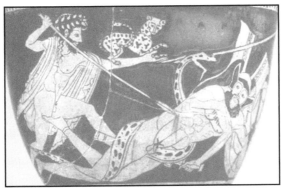

Dionysos Attacks with the Ancient Serpent to Put an End to a Giant.

On the vase above from about 510 BC, Dionysos kills a Giant. The soulish man overcomes the spiritual man. The leopard on the arm of Dionysos lets us know of Nimrod's (Herakles') crucial presence in the victory. One interpretation of the meaning of "Nimrod" is that it comes from *Nimr*, a leopard, and *rada*, to subdue. The subduer of the leopard, Nimrod, brought back the religious system of the ancient serpent (shown on the vase with a beard), and thus the Greek gods overcame the religion of the Giants, the Yahweh-believing sons of Noah.

Greek artists depicted scenes of the gods defeating the Giants on the fourteen metopes under the east pediment of the Parthenon, and they embroidered scenes of it on the ritual cloak presented to Athena with great pomp every four years. Sculptors across the Aegean Sea in Pergamum depicted the gods defeating the Giants in a 120-meter-long frieze on the Altar of Zeus. Below, we see the altar reassembled in Berlin.

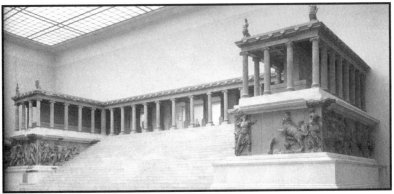

Altar of Zeus, Pergamum Museum, Berlin.

45

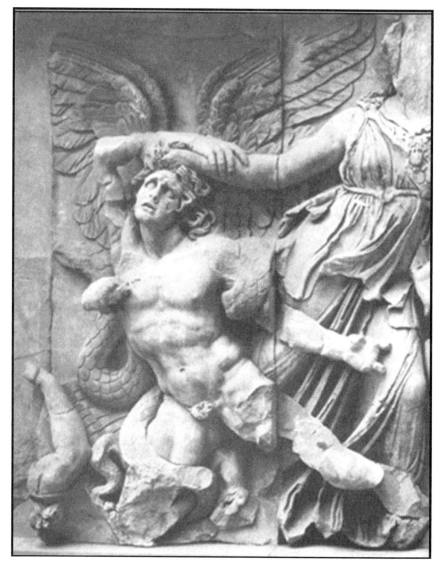

Athena and the Serpent Bring Down a Giant—A Yahweh-believing Son of Noah

Above, from the east frieze of the Altar of Zeus, Athena works with the serpent to bring down the Giant Enkelados. Athena drives his head downward as the serpent, entwined about his body with fangs locked into his breast, pulls him to earth. The wings are an indication of Enkelados' spiritual power. A victory over beings with such a connection serves to emphasize the fearful and ultimate power of Athena, the serpent, and Zeus-religion.

46

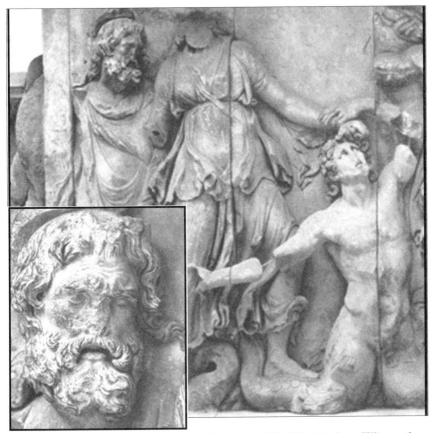

On the Altar of Zeus, Sculptors Force Nereus and His Wife, Doris, to Witness the Triumph of Zeus-religion over Their Yahweh-believing Sons

From one of the corners, the sculptors have made Nereus/Noah an observer of this horrendous defeat of his Yahweh-believing sons. His face is solemn, and he is the only man on the entire frieze who is not engaged in the battle. Greek art chronicles the great spiritual change which took place after the Flood. Greek artists often used Nereus/Noah as a constant against whom they were able to portray this great change. This device was artistically effective and historically accurate.

Nereus's wife, Doris, stands next to him. She tries to pull up one of their Yahweh-believing sons by his hair. But her gesture is futile because her son's legs have become serpentine. The iconographic message is simple: because of the serpent and its power, the Yahweh-believing sons of Noah are no longer able to stand. Revelation 2:13 refers to the Altar of Zeus in Pergamum as "the throne of Satan."

Nereus/Noah Forced to Witness the Rise to Power of Athena/Naamah

Greek artists often put Nereus/Noah in vase-scenes to witness the demise of his religious outlook and reverence for Yahweh. On the vase-scene above, the artist has placed Nereus/Noah behind two goddesses of childbirth, forcing him to witness the birth of Athena as full-grown and fully-armed. She is the deification of his daughter-in-law, Naamah, wife of Ham and sister of Tubal-kain (Genesis 4:22). Athena/Naamah inspired the rebellion instigated by her son, Hermes/Cush, and enforced by her grandson, Herakles/Nimrod.

To scholars who consider Athena's birth out of context, it seems to be some kind of myth. In context, it is history: it is what happened after the Flood. By placing Nereus/Noah in the above scene, the artist has made sure we understand the context of Athena's birth. The artist forces Noah to witness the great change coming in mankind's spiritual orientation, as embodied in the rapid rise to power of Athena/Naamah.

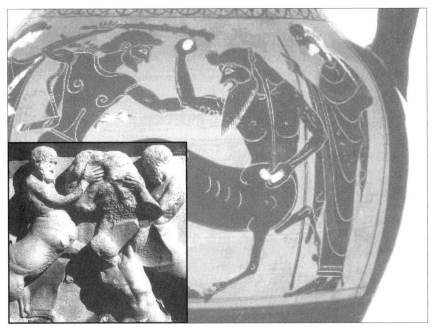

Herakles Takes Revenge on the Kentaurs as Nereus/Noah Watches

Did the painter of the above vase wake up one morning and say to himself, "Gee, I feel like painting a picture of Herakles about to pummel a half-man/half-horse with his club, with an old man holding a scepter watching. And just for fun, I'll paint some small rocks in the hands of the Kentaur." I don't think so. There is a purpose in Greek art unrecognized by the scholars because they fail to make the connection to the events described in Genesis.

After the Flood, did the majority of mankind remain faithful to Yahweh and his prophet, Noah? Absolutely not. Greek artists report that fact over and over in many different ways. On the above vase, the artist has forced Nereus/Noah to witness the thrashing that the line of Seth, represented by the Kentaur, received at the hands of Herakles. Remember that Greek artists depicted the Flood as Kentaurs (Seth-men) pounding Kaineus, representing the line of Kain, into the earth with huge boulders (see inset from the temple of Hephaistos in Athens).

The artist could have titled his painting "The Revenge of the Line of Kain." The Kentaur's rocks are very small, without any real power to do harm. After the Flood, the club of Herakles/Nimrod carries the day.

49

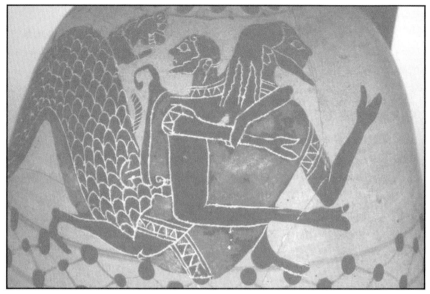

Herakles' Fear of Death Drives Him to Seek Answers from Noah

The eleventh and final tablet of the *Epic of Gilgamesh*, the Mespotamian hero, tells the story of a Deluge very similar to the Genesis account of Noah's Flood. In great fear of death and in search of the meaning of his life, Gilgamesh seeks after the one human believed to be immortal, Utnapishtim, survivor of the world-engulfing Flood.

Noah, Nereus, and Utnapishtim are one and the same person. In Genesis 6:9 we read, "Noah is a just man." The ancient Greek poet, Hesiod, wrote in his *Theogony*, "And Sea begat Nereus, the eldest of his children, who is true and lies not: and men call him the Old Man because he is trusty and gentle and does not forget the laws of righteousness, but thinks just and kindly thoughts." As David Allen Deal has pointed out in his *Noah's Ark: The Evidence*, Utnapishtim (*ut nephis tam*) in Shemitic/Hebrew means "a living beacon of righteousness."

Greek artists knew of the *Epic of Gilgamesh*, as we can see from the vase-depiction above, and they naturally expressed it in terms of his Greek counterpart, Herakles. On the vase, the hero clings to Nereus/Noah as he looks over his shoulder with dread at the monstrous figure, Kerberos, representing death. Nereus/Noah gestures as if he is responding to the plea of Herakles/Nimrod. It appears that the vase-artist is depicting these very words of Gilgamesh from the epic:

Oh woe! What shall I do Utnapishtim? Where shall I go? The snatcher has taken hold of my flesh, in my bedroom, death dwells, and wherever I set my foot, there too is death.

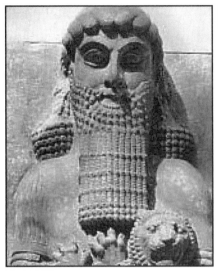

The Great Mesopotamian Hero, Gilgamesh, from the Palace of the Assyrian King Sargon II (721—705 BC)

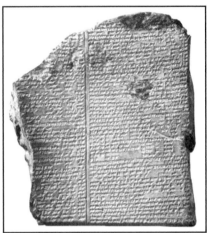

11th and Final Tablet of the Epic of Gilgamesh Featuring the Story of the Deluge

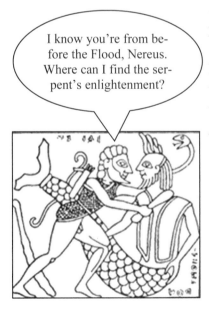

On the shield-band panel from about 550 BC, left below, the artist presents Herakles as having a different focus in relation to Nereus/Noah. The hero is no longer pleading with Noah to ease his fear of death. The inscription on the panel refers to Nereus as *Halios Geron*—"The Salt Sea Old Man." He has a snake and a flame emanating from his head. This tells us what Herakles is after—the enlightenment of the serpent. We'll see in Section III that Herakles ultimately brings his fear of Kerberos under control, and finds the enlightenment he craves in the Garden of the Hesperides.

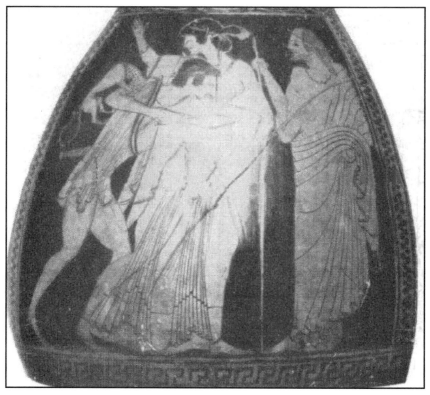

Nereus/Noah Forced to Witness the Abduction of His Daughter, Thetis

Nereus/Noah is a benchmark figure. Artists placed him in scenes as the known figure, the constant against which they could portray the great spiritual/religious change taking place after the Flood. We've seen that Greek artists placed Nereus/Noah in scenes as a witness to the gods (Zeus-religion) crushing the Giants—his Yahweh-believing sons, as a witness to the birth of Athena (the coming into power of his daughter-in-law, Naamah, from the line of Kain), as a witness to Kentaurs (the line of Seth) being pummeled by Herakles/Nimrod, and as a witness to his power and authority (in the form of Triton) being seized by Herakles and given to Poseidon. On the vase-depiction above, an artist has made Nereus/Noah a silent witness to the abduction of his daughter, Thetis, by the Zeus-worshipper, Peleus.

This abduction theme, depicted often in Greek art, was yet another way of telling the story of the triumph of Zeus-religion over the rule of Nereus/Noah and his God.

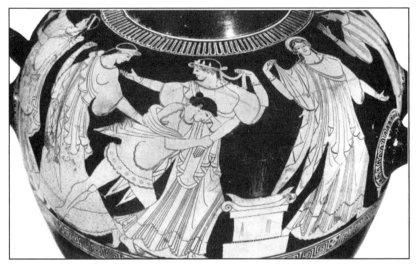

Zeus-worshipper Peleus Abducts Noah's Daughter, Thetis, from the Altar

Above, the vase-artist has intentionally placed the abduction next to an altar evoking the idea of worship, and emphasizing the great spiritual transformation about to occur. According to Genesis, Noah, immediately after departing from the ark, built an altar to Yahweh. All the women on the vase are daughters of Nereus/Noah. Not only is Peleus interfering with their worship, he is seizing Thetis and taking her away from it.

On the other side of the vase, below, the daughters, in an agitated state of motion, run open-armed to their father for help. Nereus holds a scepter, and his bottom half is a fish.

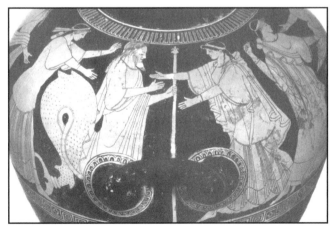

The Other Daughters of Nereus/Noah Run to Him in a Panic about Their Sister

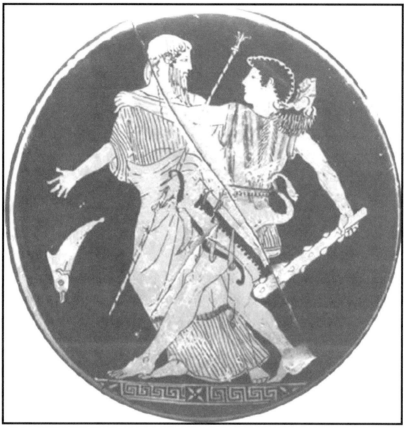

Herakles' Negation of the Authority of Nereus/Noah Enabled . . .

We've seen that Herakles played the key role in defeating the Yahweh-believing sons of Noah, and that artists often depicted him as seizing the authority of Nereus/Noah. On opposite sides of this red-figure bobbin, the artist connects the abduction of Thetis by Peleus with Herakles' successful efforts to nullify the authority of Nereus/Noah. Above, Herakles neutralizes the authority of Thetis' father, Nereus/Noah, so that Peleus can take whichever daughter he wants. Herakles does not harm Nereus/Noah; he pushes him out of the way. Mankind revered the "Wet One" for bringing mankind through the Flood. Knocking Nereus loose from the fish, one of his key identifying symbols, tells us that respect for Nereus/Noah is diminishing while respect for the physical authority of Herakles/Nimrod is becoming paramount. By knocking the fish out of his hand, Herakles says, "Your power through association with the Flood

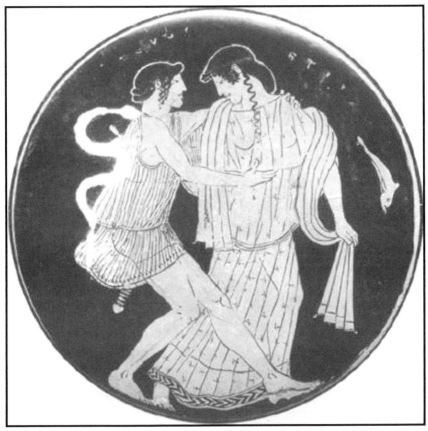

. . . Peleus to Carry Out the Brazen Abduction of Nereus' Daughter, Thetis

is done, and I'm taking over." Note that Nereus still carries the scepter. The artist tells us with his vase-painting that Herakles rebelled against the authority of Nereus; or to use their Judeo-Christian names: Nimrod (whose name means Rebel) rebelled against the authority of Noah.

On the other side of the bobbin, above, Peleus carries off Thetis, the daughter of Nereus/Noah. Note the serpent on the back of Peleus. Thereby the artist, again, with very simple imagery, tells us that the serpent is *behind* what Peleus is doing. How can Peleus get away with something so brazen? The other side of the bobbin, whereon Herakles boldly asserts that humanity no longer need answer to Noah, but rather, must answer to him, has already given us the answer.

Seizing daughters from the family of Nereus/Noah avenged the taking of women from the line of Kain by the line of Seth before the Flood.

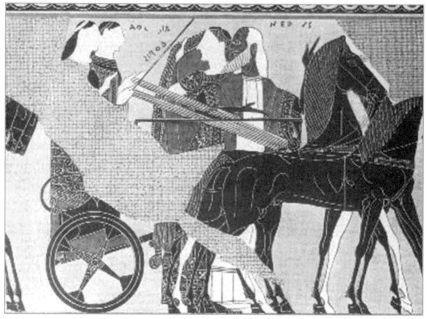

Nereus and His Wife, Doris, Watch Zeus-religion Leave Them Behind

On a scene from the partially damaged François Vase, above, we see Nereus and his wife, Doris, witnessing the wedding procession of their daughter, Thetis, and the Zeus-worshipper, Peleus. It is important to emphasize that they are not part of the wedding procession. The artist has placed them in a position to watch the procession move forward and overtake them. Respect for Noah and his wife began to fade as the lure and pomp of Zeus-religion passed them by.

While eventually the entire procession of "gods" passed by Nereus and his wife, Doris, the artist has chosen to specifically picture the chariot of Athena next to them in the scene. It is fitting, for she is Naamah/Nammu, Ham's wife from the line of Kain who inspired the rebellion.

The wedding of Peleus and Thetis was the first time all the gods of Zeus-religion came together. From the Greek perspective, the event represents the systematizing of the ancestor worship we erroneously have been taught to believe was some kind of "mythological" religion.

Greek artists told the truth about their history and their religious standpoint. Their vases explained how humanity went from the rule of a wise and just paternal figure who looked to the Creator for guidance and understanding, to the rule of men who looked to themselves and deifications of their ancestors for these things.

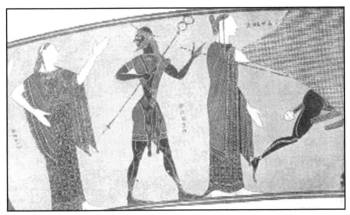

Thetis Falls in Behind Hermes and Athena.

Thetis appears again on the François Vase, this time on a different partially damaged band, above. She has fallen in behind Hermes/Cush and Athena/Naamah. She looks directly to Hermes/Cush, the chief prophet of Zeus-religion, and her leading gesture parallels his. Hermes/Cush does not follow his grandfather, Nereus/Noah, but rather his mother, Athena/Naamah. The vase-artist is telling us here that Thetis has become an integral part of Zeus-religion.

The vase-scene below takes place years later. Thetis' famous son, Achilles, has grown to be a great warrior. To obtain her son's armor, Thetis goes to Hephaistos, armorer of the gods. As the eldest son of Zeus and Hera, he is the deification of Kain, and she relies on his technical skill to protect her son. Nike's presence on the other side of the vase tells us that this is cause for a victory celebration. For more about the direct connection between the abduction of Thetis from the altar of Noah and the onset of Trojan War, see Chapter 9 of *The Parthenon Code*.

Nike Approves as Thetis Has Hephaistos Make Armor for Her Son, Achilles.

57

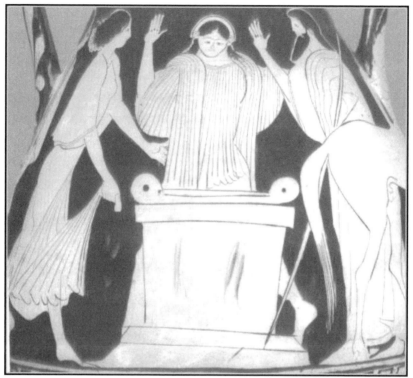

Chiron/Ham Turns His Back on the Worship of Nereus/Noah

Above, one of the sisters of Thetis runs to the altar of Nereus/Noah because, on the other side of the vase, Peleus abducts Thetis. Nereus and his wife, Doris, each with a raised right arm, offer up prayers of supplication to their God. In front of Nereus/Noah, we see the back side of Chiron/Ham, facing away from the altar. Chiron/Ham has turned his back on Noah and the altar of worship to Yahweh. Where will Chiron/Ham worship now? Let's go to the wedding of Peleus and Thetis to find out.

Opposite top, from a partially damaged scene on the François Vase, Thetis sits inside the temple awaiting her husband, Peleus, who stands outside, in front of the altar. Opposite bottom, the parade of gods approaches led by Chiron/Ham and Iris. Directly over the altar, Chiron and Peleus clasp hands in agreement and celebration. Chiron/Ham has turned his back on Noah's altar, preferring the altar of Zeus-religion. On the altar sits a kantharos, meaning "dung beetle," a symbol of transformation. Humanity's forsaking of the altar of Noah's God for the altar of Zeus-religion is an historically momentous transformation, indeed.

58

Thetis Seated in the Temple and Peleus Standing Outside by the Altar

Iris is the Rainbow. Originally the sign of a covenant between Yahweh and mankind (Genesis 9:12-17), the Rainbow now becomes a sign of amity between Greek humanity and the gods of Zeus-religion—in the larger view, mankind's humanistic covenant with its own ancestors. Iris, on the vase-scene below, is now a messenger of Hera and Zeus. She carries the *kerykeion*, or herald's staff. One of the serpent heads on the end of the staff looks to the past dominance of the way of Kain; the other head looks to the future dominance of that religious viewpoint.

The Greek account of the first assembly of the gods (ancestors) before their own altar corresponds in many key respects to the Babylonian and Sumerian accounts (see pages 21 - 22).

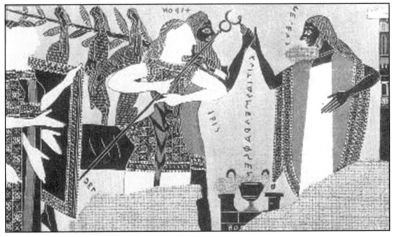

Peleus, Greeting Chiron and Iris at the Head of the Wedding Procession

59

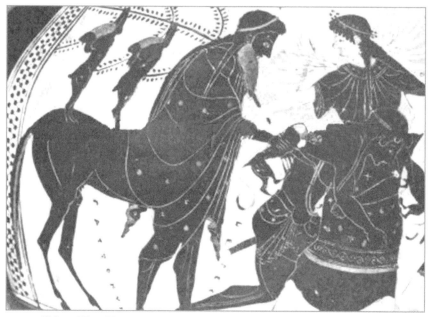

Chiron/Ham Places a Lion on the Back of Peleus as He Abducts Thetis

On the above vase-scene, Chiron touches the back of Peleus with a miniature lion, a symbol of earthly rule. In this way, he places his blessing on Peleus, and as Peleus is an ardent Zeus-worshipper, on Zeus-religion itself.

Why was Chiron/Ham so interested in the welfare of Peleus? Some ancient commentators, including Apollodorus, say that Peleus was his grandson by one of his own daughters. This makes sense as Chiron would want his offspring to prosper. It was said that Chiron/Ham protected Peleus from the attacks of hostile Kentaurs, and that he told him how to win the love of Thetis.

Some ancient stories about the demise of Chiron/Ham suggest that he ultimately regretted abetting the development of Zeus-religion. The gist of those stories is that poison from Herakles put him in such continuous pain (a wound that would not heal) that he no longer wished to be immortal. Mythologist Edward Tripp suggests that it was "the fate of his people" (the Kentaurs—the line of Seth) that made him want to end his life. We can trace the "poison" of Herakles/Nimrod to his father, Hermes/Cush, and in turn to his grandmother, Naamah/Athena—the woman from the line of Kain whom Chiron/Ham brought through the Flood.

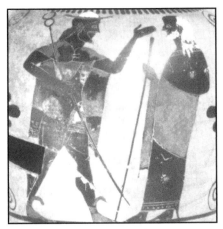

Hermes Lectures Nereus

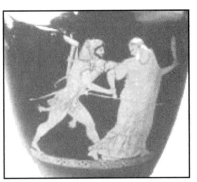

Herakles Grabs Nereus

Above are two Nereus/Noah vase-scenes that I was unable to fit into the foregoing narrative. In the scene to the left, Hermes interacts with Nereus; in the scene to the right, Herakles interacts with him.

Greek vase-painters were masters at portraying movement and gesture. In the one scene, Hermes lectures Nereus. The body language of the figures shows that this is no dialogue; Hermes is doing all the talking. He may be giving Nereus an ultimatum: "Stay out of the way. Don't interfere with the direction we're taking." It even looks as if he could be saying "You're fired!" There is no doubt that the one with the serpent-entwined scepter will prevail.

In the scene with Herakles, the artist has put a fish in the left hand of Nereus to make sure we can identify him. He doesn't make his bottom half a fish because he uses the human lower-half of Nereus to show motion. Nereus is headed somewhere, going about his business. Herakles surprises Nereus from behind making him turn his head. Herakles is literally "strong-arming" Nereus. He grabs the wrist that holds the scepter, because that is what this is about: taking Noah's authority and putting a stop to his rule.

Again and again, Greek artists tell us who they are, where they come from, and what they believe.

SECTION III

Herakles' Boast on the Temple of Zeus

In the following pages, as we take a look at the labors of Herakles depicted on the temple of Zeus at Olympia, let's keep in mind that the Greeks created the living basis of our culture, and that their artists created their sculptures and paintings to be understood—then and now.

In an article about the recent restoration of America's first Cathedral, the Basilica of the National Shrine of the Assumption of the Blessed Virgin Mary in Baltimore, Suzanne Singleton wrote, "As cathedrals were built for worship throughout the history of the Catholic Church, they were used additionally as places of learning about Catholicism. Because many people were illiterate, the stained-glass windows acted as teachers to parishioners who 'read' the pictures of the Trinity, Mary, the angels and saints and other religious depictions."

While stained-glass windows told the stories of Christ and His apostles in Catholic cathedrals, the sculptures on ancient Greek temples boasted of the triumph of Zeus-religion. Sculpted images of the Catholic saints appear in many cathedrals. Many parishioners pray to them, believing that these once-mortal beings will answer, and help them in some way. So it was with the Greeks who prayed to their ancestors, expecting an ear and some answers from their "saints" in the way of Kain.

We can understand the stories the stained glass windows tell. They illustrate the events pertaining to the foundation of early Christianity. Likewise, we can understand the stories Greek sculptors have left for us. They tell us the early history of Zeus-religion. The twelve metopes on the temple of Zeus at Olympia, completed in about 450 BC, display the key events in the adult life of Herakles, and overall, they chronicle mankind's rebellion after the Flood.

While Nereus/Noah does not appear on any of the sculptures of the labors of Herakles at Olympia, there is no mistaking that they all contribute to telling the story of the Salt Sea Old Man's overthrow by the unified efforts of Athena/Naamah, Hermes/Cush, and Herakles/Nimrod.

The 12 Labors of Herakles on the Temple of Zeus at Olympia:
Chronicling Mankind's Rebellion after the Flood

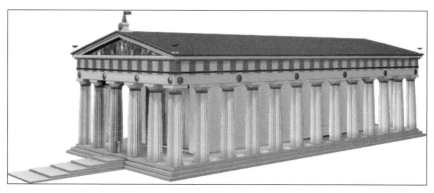

Temple of Zeus at Olympia from the Northeast

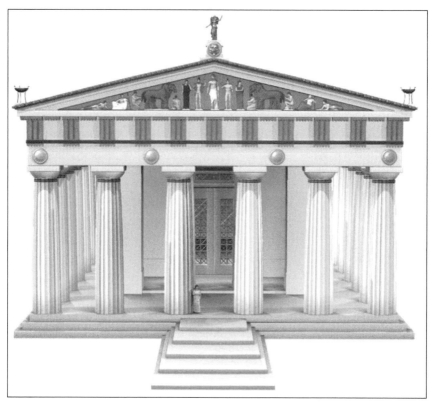

The East Entrance to the Temple of Zeus at Olympia

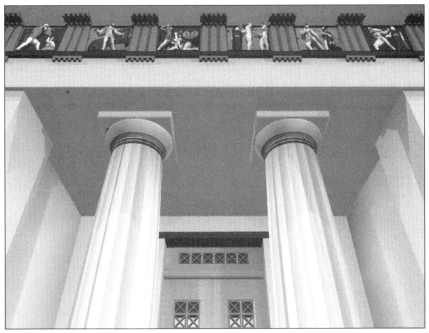

Looking up at the Six Metopes from the East Porch

On the temple of Zeus at Olympia, the Greeks used the twelve labors of Herakles to summarize their boast that, after the Flood, they had pushed Noah and his God out of the picture and exalted man as the measure of all things. Depictions of six labors appeared on the east side, and six on the west side. The viewer had to step under the pediment and up onto the porch to see the metopes (square sculptures).

After the Flood, Yahweh instructed mankind to be "fruitful and increase and fill the earth and subdue it" (Genesis 9:1). That included subjecting every living animal of the earth, all the fishes of the sea, and every flyer of the heavens. Nimrod/Herakles began to subdue all the animals of the earth. Genesis 10:9 refers to him as "a master hunter before Yahweh Elohim." According to Chapter 7 of the Book of Jasher, once Nimrod's fame spread and he obtained great power, he ceased walking in the ways of Yahweh and began to worship idols.

Greek art shows that Herakles/Nimrod turned to Zeus-religion, and began worshipping his ancestors. As the Greeks depict his first three labors, Herakles is still subduing the animals of the earth, not unto Yahweh, but rather unto Athena and Hermes.

Herakles Chokes to Death the Lion of Nemea

Herakles, the Nimrod of Genesis transplanted to Greek soil, began what was originally a scriptural mandate to subject all the animals of the land, sea, and air to mankind by stalking the ferocious king of the beasts, the lion of Nemea. When Herakles' arrows bounced off the beast, he realized it was invulnerable to weapons. The hero met the animal face to face and strangled it with his bare hands, as in the vase-depiction above.

Herakles dressed himself in the pelt, with the lion's head serving as a kind of hood. Artists used his lion pelt (vase-depiction, opposite) and his club to identify him in vase-scenes and in sculpture. He killed the king of the beasts using only his courage, his mind, and his hands as weapons; and thenceforth, he boasted of possessing the leonine powers with which he terrified and stalked his enemies.

On the metope, Athena and Hermes stand by the victorious Herakles. He has subdued the king of the land beasts to them—his father (Hermes/Cush) and his grandmother (Athena/Naamah). By the time he has completed all twelve labors, Zeus-religion will rule the Greek world and its future. Athena and Hermes look to Herakles as the hero and king of humanity who, through his conquests and labors, restores the serpent's system, and brings back and enforces the way of Kain after the Flood.

West Metope One: The Nemean Lion

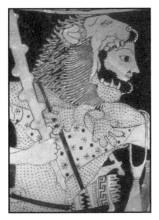

**Herakles Wears the
Lion's Head, about 500 BC**

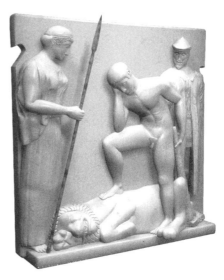

67

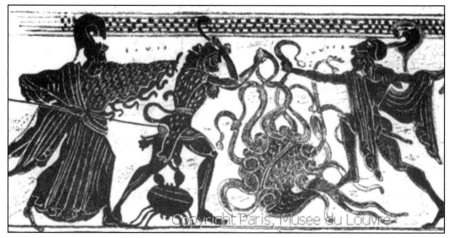

**Athena Assists Herakles and His Nephew Iolaüs Defeat the Fearsome
Sea Creature, the Hydra of Lerna.**

The Hydra, or sea creature, the half-sister of the lion of Nemea, bred in the lake of Lerna, went forth into the plain and ravaged the cattle and the countryside. The Hydra had a huge body, with nine heads, eight mortal, but the middle one supposedly immortal. On the above vase-depiction from about 500 BC, we see Herakles and his nephew Iolaüs, cutting off the Hydra's mortal heads and searing the necks with fire. A large crab attacks Herakles' legs, but Athena, again supplying the key religious connection, is there to see to it that the hero prevails over any and all sea monsters.

Athena carries her spear into the action and throws her serpent-trimmed *aegis*, or goat-skin, into the air behind Herakles. Because of Athena's association with it, the word aegis has come into our language meaning "authority" and "protection." Throughout his labors, Herakles operated under the aegis, or authority and protection, of his grandmother Athena/Naamah from the line of Kain. The success of all his labors and all his other great victories served to elevate Athena's glory and power.

The sculptors of the metope did not have room for all the figures and so chose to depict only Herakles and the Hydra on it. The average Greek knew the rest of the story.

So far, Herakles has subdued the king of the land animals and the most dangerous of the sea animals. In his next labor, he will subdue the most dangerous and vicious fowls of the air.

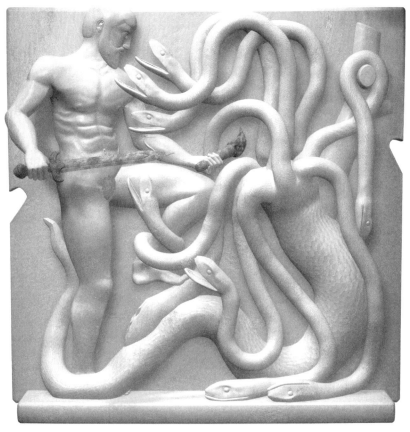

West Metope Two: The Lernaean Hydra.

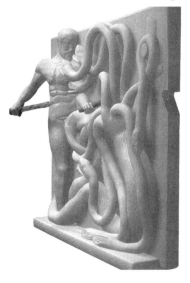
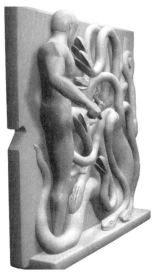

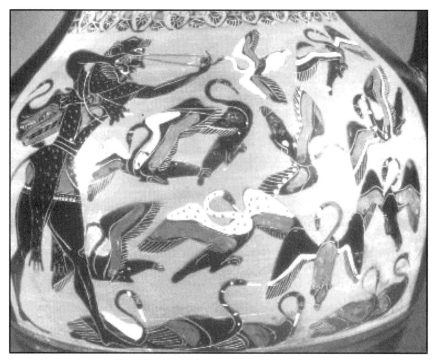

Herakles Kills the Vicious Birds of Lake Stymphalos

Razor-beaked, man-eating birds ravaged the region surrounding Lake Stymphalos in Arcadia. To help Herakles kill the birds, Hephaistos (the deified Kain) made bronze castanets for him. By clashing these on a mountain above the lake, he spooked the birds. Once they took flight, he killed them with his slingshot, as above. It was easy to show him killing the birds on vases, but next to impossible in sculpture. The metope shows him instead presenting the dead birds to Athena.

Athena protects Herakles when he kills the lion, the Hydra, and the Stymphalian birds. Thus, symbolically, the mastery of "every living animal" is not only his, but hers—with the exception of the serpent, who masters her, her son Hermes/Cush, and her grandson Herakles/Nimrod.

The serpent is the one animal that Herakles does not subject to the rule of mankind. Instead of ruling over the serpent as per Yahweh's instructions in Genesis 9:1-3, Herakles subjects himself to the serpent's power. He looks up to Zeus, Athena, and Hermes with adoration. Zeus is the serpent transfigured into an image of the first man, Adam. Another way to put it: Zeus is the serpent-friendly Adam. Athena is Naamah, who

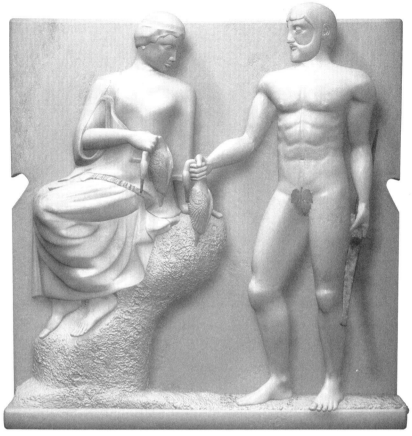

West Metope Three: The Stymphalian Birds

represents, and in a very real sense *is* the reborn serpent-friendly Eve after the Flood. As a boast of that, she wears a serpent-fringed aegis with the Gorgon Medusa, the head of serpents, on it. Hermes, in reality her son Cush, has become the chief messenger of Zeus-religion, carrying as a symbol of the source of his authority a kerykeion, a scepter with facing serpent heads on it.

Herakles subjects himself to his father and grandmother who have subjected themselves to the serpent's authority, and so while appearing to carry out Yahweh's instructions, he violates them in the most signifi-cant way possible. Herakles takes the mandate recorded in Genesis, but changes its orientation away from Noah and Yahweh toward the serpent and the way of Kain. Properly understood, Greek sculpture and vase painting tell us the early history of humanity with marvelous lucidity.

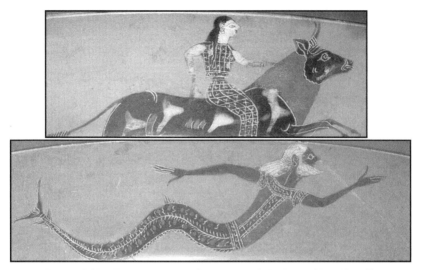

Europa Rides Zeus the Bull to Crete toward the End of Noah's Life

In the first three labors, the sculptors have told us about the subjection of the animals of the land, sea, and air to Herakles—a devotee to Hermes, Athena, and Zeus-religion. In the next two labors, the Cretan Bull and the Kerynitian Stag, the artists tell us how quickly Herakles spread the idea of Zeus-religion throughout the Greek world.

As the "father of gods and men" and a picture of the original Adam, Zeus is humanity's most significantly fertile ancestor. Artists chose an animal known for its fertility to represent him and the spread of his religion—the bull.

In a recent issue devoted to ancient Crete, the editors of an archaeological journal made a point to emphasize that European civilization began there. Greek artists, long ago, said the same thing: Europa, daughter of the king of Tyre, caught the eye of Zeus. He transformed himself into a bull and carried her across the Mediterranean Sea to Crete where she gave birth to several Zeus-religion enthusiasts, and that's where European civilization began.

In about 540 BC, a Greek artist expressed that truth very simply, as we can see on the above vase. On one side, Europa rides through the sea on the back of Zeus the bull. On the other side, we learn the time-frame; for it pictures Nereus/Noah, the Old Man of the Sea. According to Genesis, in the latter part of Noah's life, Yahweh dispersed humanity after

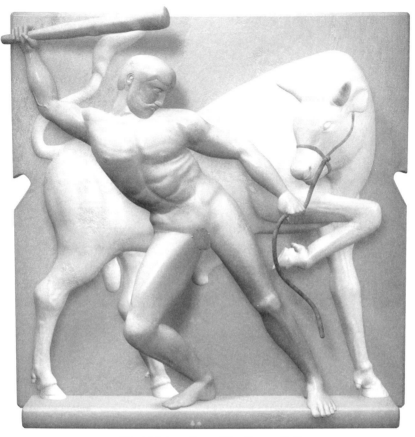

West Metope Four: The Cretan Bull

their attempt to unite in Babylon by confounding their one language into many. Genesis describes those who then sailed about the Mediterranean as "coastlanders" (Genesis 10:5). The Greeks ignore Noah's God and instead give Zeus credit for bringing humanity to Crete from the Mideast, thereby establishing on that island the earliest foundations of Greek civilization, and European civilization as well.

Herakles brought the bull, symbolizing Zeus and Zeus-religion, from Crete to mainland Greece, and ultimately released it to go where it would. On the metope, Herakles' club is not raised against the bull, but rather against anyone who would interfere with his spreading of Zeus-religion. How quickly all this occurred is the subject of Herakles' next labor, the Kerynitian Stag.

73

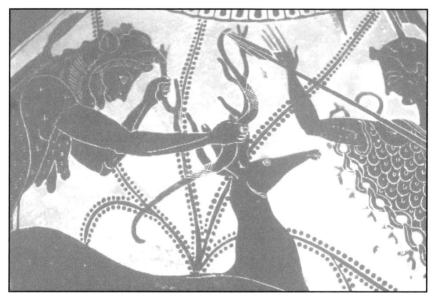

Wearing Her Serpent-trimmed Aegis, Athena Helps Herakles Capture the Stag

A stag is a male red deer. If you have ever seen one on the move, you know how quick they are. It took Herakles over a year to run down the Kerynitian Stag. The previous labor speaks of the spread of Zeus-religion as symbolized by the bull. This labor is directly related and demonstrates how quickly that happened.

The spiritual rebellion against Noah and his Yahweh-believing children was not only a matter of speed, but of secrecy. On the terracotta figurine, opposite, Gaia (Earth) hands the reborn line of Kain, in the form of the earth-born child, to Athena (see vase-depictions on pages 17 and 23). Kekrops, half-man/half-serpent, raises his fingers to his mouth, cautioning silence about this event because Zeus-religion is just beginning to grow and is not yet triumphant. I have come to think that Kekrops, who is sometimes called the first king of Athens, represents Zeus, originally worshipped as the ancient serpent, in the process of being transfigured into an image of Adam (see Chapter 13 of *The Parthenon Code*).

In this labor, Herakles/Nimrod also pays homage to Artemis. Like Athena, she also represents an aspect of Naamah. Homer referred to Artemis as "Mistress of Wild Animals," which gives her credit, instead of Noah, for bringing the animals through the Flood. That's why the deer is sacred to her, and she is pleased to allow Herakles to keep it.

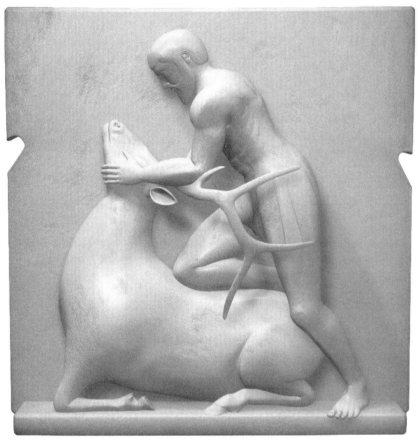

West Metope Five: The Kerynitian Stag

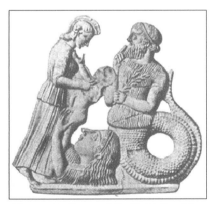

**Terracotta Scene of the Rebirth of the
Line of Kain after the Flood**

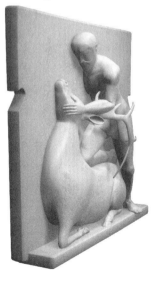

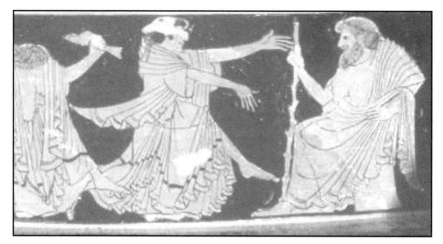

The Daughters of Noah Run to Him, Demanding That He Do Something about the Abduction of Their Sister, Thetis, by the Zeus-worshipper, Peleus

Now Herakles, for the first time, meets serious human opposition to the spread of Zeus-religion, and it comes from women, not men.

Chapter 10 of *The Parthenon Code* presents a red-figure vase from about 490 BC by an artist named Kleophrades. In a series of panels, he tells the story of how Noah's daughters became the Amazons. First, they become outraged as the Zeus-worshipper, Peleus, abducts their sister, Thetis. Then, when they run to their father, Nereus/Noah, and demand that he take action, he just sits there (pictured above). Then taking matters into their own hands, they arm themselves and become the Amazons. Next, they advance against Herakles, the leader of the rebellion against their father. But then Herakles kills the leader of the Amazons, Hippolyte, ending the threat to the growth of Zeus-religion.

The scene opposite, from the Kleophrades vase, shows Herakles killing Hippolyte. The sculptors of the metope may have relied on the work of Kleophrades in their similar depiction of Hippolyte's death. Note that the next Amazon to advance against Herakles has a Kentaur painted on her shield, identifying her and her sisters as part of the line of Seth.

On the metope, Herakles takes from Hippolyte her belt, a symbol of the source of her authority. She had received the belt from Ares, the Greek version of Seth. Again and again, in many different ways, Greek artists celebrated the victory of the way of Kain over the line of Seth.

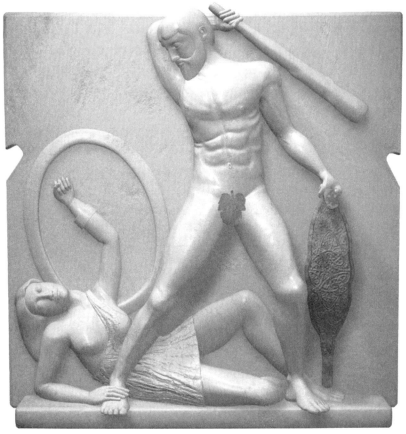

West Metope Six: The Belt of Hippolyte

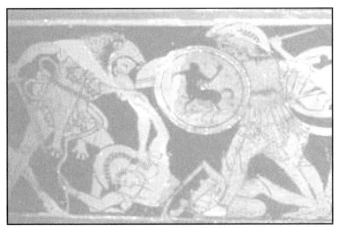

From the Kleophrades Vase, Herakles Kills Hippolyte

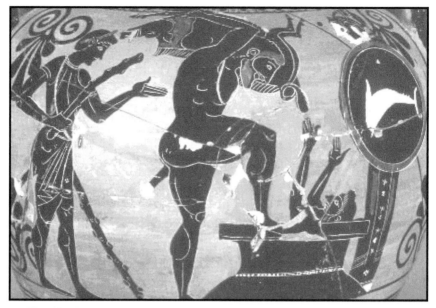

Herakles Dumps the Boar on Eurystheus as an Approving Athena Stands By

Herakles means "the glory of Hera," and by embracing and spreading Zeus-religion, he did restore her glory as the wife of Zeus and the original serpent-friendly Eve in the ancient paradise. As a story-telling device, Greek artists and poets made Hera out to be resentful that Athena, the post-Flood reborn serpent-friendly Eve, received more glory from Herakles than she. Throughout his life and labors, Athena encouraged Herakles while Hera opposed him.

Hera kept Herakles from being born just long enough so that his weakling cousin, Eurystheus, would be born ahead of him and become king in his stead. Then, when Hera drove Herakles so mad that he murdered his wife and children, she saw to it that as punishment and humiliation for his crimes, he had to perform whatever labors King Eurystheus demanded. The capture of the boar of Eurymanthia expresses the boiling animosity Herakles carried toward his cousin, Eurystheus.

Most extant vases of the subject (see above), and the metope, depicted Herakles about to dump the captured beast on the frightened Eurystheus who hides in a jar. Athena's presence shows her approval of Herakles' scoffing at the authority of Eurystheus. Athena (Naamah revered as goddess of wisdom, war, and crafts) used her grandson Herakles to instill fear in those who would resist her rule after the Flood.

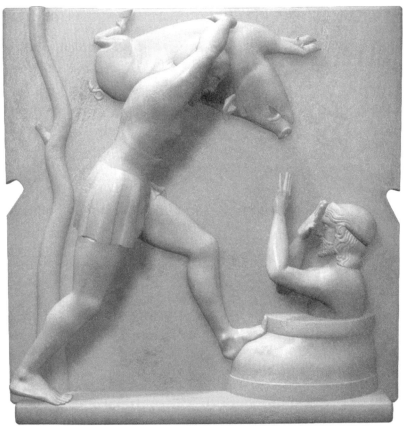

East Metope One: The Erymanthian Boar

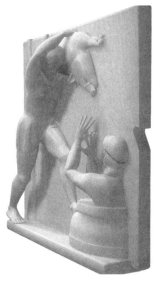

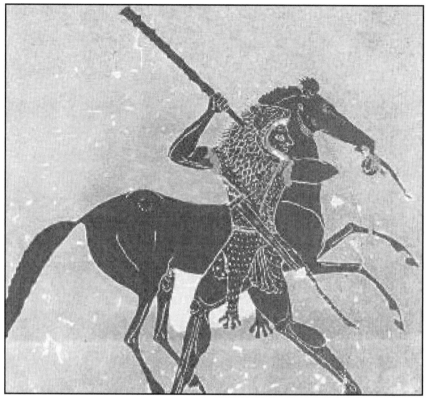

Herakles Captures One of the Mares of Diomedes, a Son of Ares/Seth

Diomedes, a king in Thrace, fed his mares on human flesh. Herakles, with the company of friends, seized the animals and entrusted them to his friend Abderos. Abderos turned his back once too often, and the mares ate him. Herakles built the town of Abdera to honor his friend.

On the vase-scene above, a head and arm hang from the mouth of the man-eating horse. It could be Herakles' unfortunate friend, Abderos, or Diomedes himself, because Herakles killed Diomedes and fed him to his horses. The mares became tame after they ate their master and Herakles set them free. Later wild beasts killed them on Mount Olympus.

This labor is about Herakles conquering the region of Thrace on behalf of Zeus-religion and the line of Kain. The poets specifically mentioned that Diomedes was a son of Ares, the Greek version of Adam's and Eve's youngest son, Seth. And they also specifically mentioned that Herakles' friend, Abderos, was a son of Hermes, the Cush of Genesis.

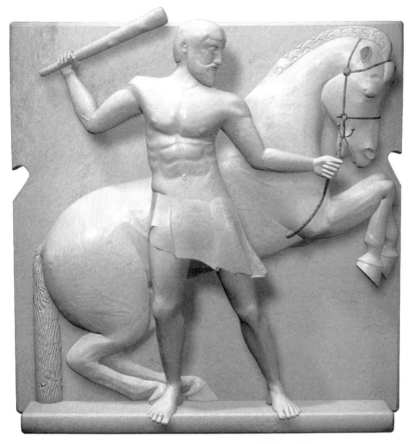

East Metope Two: The Mares of Diomedes

 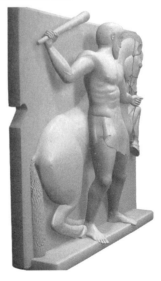

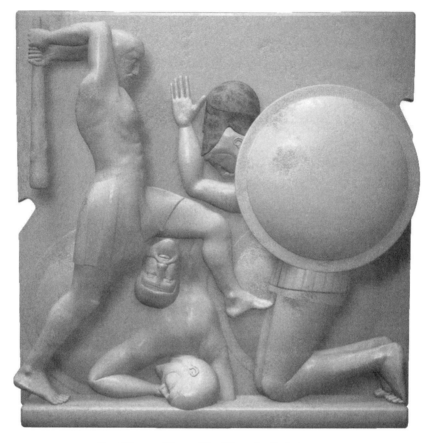

East Metope Three: The Three-bodied Geryon

While all twelve metopes present a summary of the triumph of Zeus-religion, east metopes three and four present a summary within a summary. These were the two over the east entrance, and their message tied in directly with the great gold and ivory idol-image of Zeus seated inside. These two interrelated metopes explained, simply and graphically, how Herakles had enabled Zeus-religion to dominate the Greek world.

Above, Herakles kills the triple-bodied warrior, Geryon. There were no triple-bodied warriors in ancient days, any more than there are triple-bodied warriors today. And yet here we see Herakles, having beaten two of Geryon's bodies to death, about to mercilessly club the third. What could a triple-bodied man signify? Noah had three sons: Shem, Ham, and Japheth. Nimrod's rebellion reached its heights during the time of their rule, after the death of Noah. By killing the triple-bodied Geryon, the

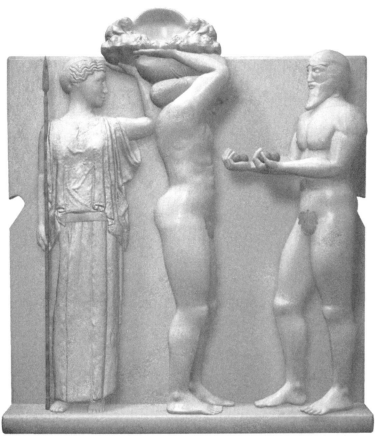

East Metope Four: The Apples of the Hesperides

hero, Herakles, is figuratively overcoming the spiritual authority of Noah's three sons. After their deaths, Herakles reigned unchallenged. But where did Herakles get his authority? The adjacent metope answers that question. Athena's power, combined with great efforts of his own, has enabled Herakles to push away the heavens and with them the God of the heavens. Herakles has gained access to the golden apples from the serpent's tree in the Garden of the Hesperides. Atlas offers him the apples, the forbidden fruit once offered to the first couple, Adam/Zeus and Eve/Hera, by the ancient serpent. Thus, these two metopes over the sacred east entrance commemorate the successful rebellion of Nimrod/Herakles, celebrate an end to the interference of Noah's oppressive God with Greek humanity, and acknowledge mankind's return to the way of Kain and the wisdom of the ancient serpent.

As the Greeks looked up at the adjacent Geryon and Hesperides metopes over the doorway and walked under them, they surely understood who and what it was that had enabled Zeus to take his place of rule and be seated on the huge throne before them inside his temple. Thanks to Herakles/Nimrod, Zeus-religion ruled the Greek world.

For the most part, the ancient post-Flood world dispensed with Noah and his God, and instead elevated and enthroned humanity.

Zeus displays Nike in his right hand, boasting of mankind's Victory over Noah and his God. Zeus is the serpent-friendly Adam of Genesis. Only one other god (deified human ancestor) is ever pictured holding Nike in her hand—Athena/Naamah, the woman from the line of Kain who defied Noah and re-welcomed the serpent's enlightenment after the Flood. Herakles/Nimrod, by his great deeds, elevated both these ancestors to their positions of undisputed supremacy in the Greek world.

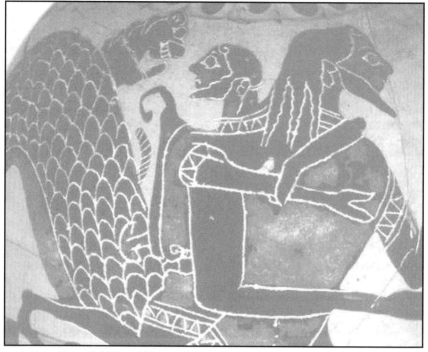

Once Hounded Himself by the Evil Beast, Herakles Has Learned to Make Kerberos His Ally, Using the Fear of Death to Frighten and Control Others

While the Greeks called Nimrod Herakles, the Sumerians and Babylonians called him Gilgamesh, making him the hero of mankind's oldest surviving written epic. In the epic, having a pressing fear of death, Gilgamesh/Herakles/Nimrod seeks for the meaning of life from Utnapishtim (Nereus/Noah), the man who brought humanity through the Flood.

On the above Greek vase from about 600 BC, which we've seen before on page 50, Herakles clings to Nereus/Noah for answers and security, looking frightfully over his shoulder at the terrifying hound, Kerberos, the evil spirit bearer representing death and Herakles' fear of it.

By the time Greek religion became systematized, Herakles had overcome his great fear. On the metope, he has Kerberos under control. The leash with which Herakles manages the beast parallels Hermes' kerykeion—identifying him as the chief prophet of Zeus-religion. There is no need for Herakles to fear death any longer: he has conquered the world on behalf of Athena, Hermes, and Zeus, and they have made him an immortal god as a reward for what he has done for them.

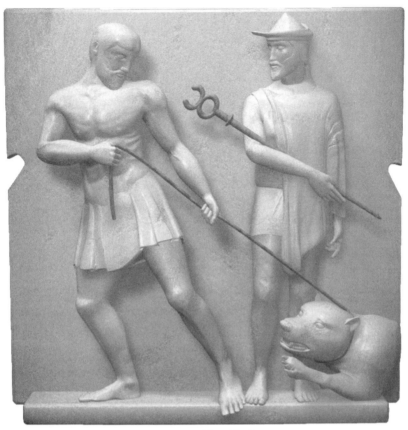

East Metope Five: Kerberos

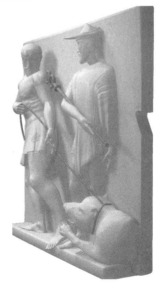

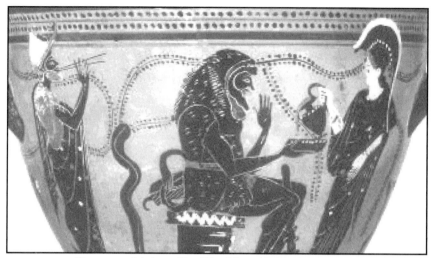

Hermes and Athena Fete Herakles with Music and Wine

Herakles had to remove in a single day the dung of the cattle of Augeias, which had accumulated over centuries. Herakles made a breach in the foundations of the cattle yard, and then, diverting the courses of the Alpheius and Peneius rivers which flowed near each other, he turned them into the yard, having first made an outlet for the water through another opening, and thus washed away all the dung.

The ancient poets did not specifically mention Athena's role in this labor, but as we can see from the metope itself, the sculptors gave her credit for this great technological feat. Athena showed the hero when, where, and how to dig. Note that the implement of Herakles parallels Athena's spear. Herakles sought the summit of human attainment. Here we have a vivid and pointed boast from the sculptors of what they thought was possible when humans devoted to Zeus-religion aligned themselves with the spirit of Athena, the reborn serpent-friendly Eve after the Flood, and exalted mankind as the measure of all things.

For those who embraced Zeus-religion, this was a positive, uplifting, and fitting final labor of Herakles. The apostle Paul wrote that he could do all things through Christ Who strengthened him. This is the same kind of message, but to a different, even opposite, higher power: Herakles and those who emulate him can do all things through Athena who strengthens them. On the above vase, Hermes/Cush and Athena/Naamah thank Herakles/Nimrod at the conclusion of his twelve labors.

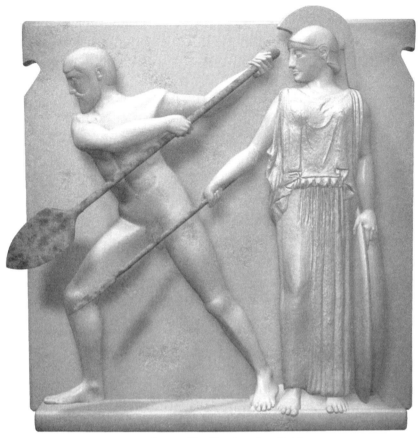

East Metope Six: The Augeian Stables

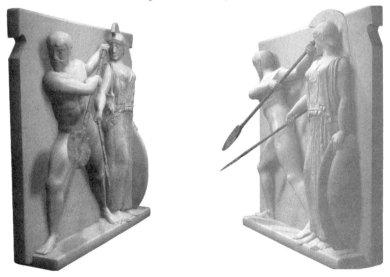

Hermes and Athena are the only gods depicted as helping Herakles throughout his labors. Why is this? The Greek word for god is *theos*, for goddess, *thea*, and for gods, *theoi*. The root of these words is *the*, and it means "placer." Athena and Hermes are the hero's most important gods (theoi) because, as Herakles' closest ancestors, they directly *placed* Herakles into existence, and motivated him to embrace the way of Kain, seeking the serpent's enlightenment. Herakles is the Nimrod of Genesis. His father, Hermes, is the Cush of Genesis. Herakles' grandmother, Athena, is the Naamah of Genesis.

Understanding that the gods are ancestors or "placers" helps us see why Zeus, a deification of the first man (the serpent-friendly Adam), is the supreme "placer" in the Greek religious system. Homer called him "the father of gods and men." That makes him the father of "placers" (ancestors) and men. The meaning of god, goddess, and gods in Greek also helps us see why Athena—the deified woman Naamah—was worshipped as the greatest "placer" in the post-Flood world.

With a better understanding of why only Hermes and Athena appear on the metopes, let's review the boasts of Herakles in his twelve labors, beginning on the west side of the temple of Zeus. On the first three metopes, Herakles boasts of his domination over the creatures of the land, sea, and air. He has subdued them all—without Yahweh's help. It is his father, Hermes, and his grandmother, Athena, who enable him.

On the Cretan Bull and the Kerynitian Stag metopes, Herakles boasts of bringing Zeus-religion from Crete to the mainland, and spreading it very quickly.

On the next metope, he boasts of crushing the Amazons—Noah's outraged Yahweh-believing daughters.

On the first metope on the east side, the Erymanthian Boar, Herakles boasts of his disrespect for the authority of his timid cousin, Eurystheus.

On the next metope, the Mares of Diomedes, he boasts of crushing the line of Seth in Thrace.

Then, as Herakles bludgeons the 3-bodied Geryon, he boasts of overcoming the authority of the three sons of Noah, enabling him in turn to boast of his unhindered access to the serpent's golden apples in the Garden of the Hesperides. The apples are golden because they represent

what is considered the most valuable commodity in Zeus-religion—the Creator-defying "wisdom" of the ancient serpent.

On the Kerberos metope, Herakles boasts of overcoming his fear of death; and thereby, of attaining immortality along with his ancestors.

And on the Augeian Stables metope, he boasts of the ability to perform great technological feats, under the tutelage of Athena.

In sum, one great boast after another. All twelve boasts lead up to the grand boast of Zeus-religion: Yahweh and his prophet, Noah, are out of the picture; and humanity itself, in the figure of Zeus, sits enthroned and victorious within the temple. The ancient serpent's "wisdom" has been fully embraced.

After their transgression in the Garden of Eden, a place where Yahweh often made His presence known, Adam and Eve felt ashamed of their nakedness. In stark contrast, with Yahweh forced out of the picture, and His presence excluded from mankind's recognition and activities, the naked hero, Herakles, stands unashamed and proud on the temple of Zeus. And all the adherents to Zeus-religion stand unashamed and proud along with him.

Boasting in the flesh and in the pride of man, Zeus-religion disconnected humanity from its Creator and exalted mankind's ancestors in the way of Kain. As we shall see in the final section, that same spirit in a slightly different form rules the scientific and academic worlds today. The idolized "heroes" of mankind continue to push the Creator out of the picture—out of His Own creation, no less. While the Greeks welcomed the idea that the ancient serpent's "enlightenment" was to be coveted, today's leading scientists and academics go a step further: they welcome the abominable notion that they are actually *descended* from serpents.

SECTION IV

The Mainstream's Blindness to Our Origins

What ancient Greek artists tell us about mankind's history is so plain to a simple understanding, we must ask why the scholars do not see it. The answer is that Darwinism has thoroughly polluted the mainstream sciences, not the least of which is anthropology, the study of humanity's beginnings. Today, mainstream anthropologists do not study the record of our origins that our ancient ancestors have left us in their art and literature. Instead, they study chimpanzees. This is very sad, pitiful even. These grown men and women work diligently and proudly in an effort to find the evidence that will finally "prove" that they themselves, along with their vaunted intellects, are the products of unintelligent chance, with no expectation of immortality.

The pernicious notion that we evolved from slime, snakes, and monkeys has hardened into a quasi-religious, uncompromising dogmatism. The idea of a Creator/Designer is heretical to the atheistic teachings of Darwinism, and therefore, no evidence from any field that points to a Creator/Designer can be allowed to disrupt that closed system of intellectual pretension.

The Book of Genesis asserts that "In a beginning, Created by the Elohim [God] were the heavens and the earth." It goes on to say that God created Adam from "the soil of the ground," blew into to him "the breath of the living," and that he thus became "a living soul." It further states that God made Eve out of Adam, and from this first couple, created by God, all humans today, through Noah and his wife, are descended.

According to the Slime-Snake-Monkey-People (SSMPs), this cannot be true. (I call them SSMPs, not because they are, but because they think they are. The term gets right to the heart of their beliefs, as opposed to the high-sounding euphemisms Darwinist, evolutionist, and naturalist. And since they firmly believe that they evolved from slime over millions of years through a countless series of random mutations, we are well within the bounds of propriety to also refer to them as mutants).

The story of Adam's and Eve's transgression in the garden, and Noah's Flood, must be considered fairy tales by the SSMPs. An SSMP cannot consider any evidence at all for these events, because within his or her religious and philosophic framework of belief, they are not possible. Since they are not possible, those who give credence to these events must be looked upon with contempt. Mutant mythologist and Slime-Snake-Monkey-Academic (SSMA) Joseph Campbell expresses this contempt most succinctly:

No one of adult mind today would turn to the Book of Genesis to learn of the origins of the earth, the plants, the beasts, and man. There was no flood, no tower of Babel, no first couple in paradise, and between the first known appearance of men on earth and the first building of cities, not one generation (Adam to Cain) but a good two million must have come into this world and passed along. Today we turn to science for our imagery of the past and of the structure of the world, and what the spinning demons of the atom and the galaxies of the telescope's eye reveal is a wonder that makes the babel of the Bible seem a toyland dream of the dear childhood of our brain.

Now let's see how Campbell goes about denying one particular piece of independent evidence that points to the truth of Genesis. In his *The Masks of God: Occidental Mythology*, he features an illustration of a Sumerian seal from 1500 BC, below. Here we have a man, a woman, a

tree, and a serpent. We think immediately of Eden. But Campbell writes that this "cannot possibly be" the representation of a lost Sumerian version of what happened in Eden. Why not? Because, he writes, there is no

sign of divine wrath or danger to be found. There is no theme of guilt connected with the garden. The boon of the knowledge of life is there, in the

sanctuary of the world, to be culled. And it is yielded willingly to any mortal, male or female, who reaches for it with the proper will and readiness to receive.

But this is exactly why it is Eden. This is the view of the events in the garden taken by Kain (Cain) and those who embraced his way. They defied and ultimately dispensed with the angry God, so He and His wrath are not going to show up here. There is no guilt because there is no sin; there is no sin, or falling short of the ideal, because, according to the line of Kain, Adam and Eve did the right thing in taking the fruit. In Genesis 3:14, Yahweh condemned the serpent to crawl on its torso and eat soil. On the Sumerian seal, the serpent rises to a height above the seated humans. Why? Those who hold to the belief system of Kain revere the wisdom of the friendly serpent who freely offers the fruit of the tree of knowledge, enlightening the two progenitors of all humanity so that they and their offspring might be as gods, knowing good and evil.

How do we explain the fact that Campbell misses something so obvious and so basic to the study of what he calls mythology? He must ignore any and all evidence and insights which contradict his atheism or his whole system falls apart. Note that Campbell does not refer to the Eden connection as improbable or unlikely, but as impossible, as something that, in his words, "cannot possibly be." As a Slime-Snake-Monkey-Academic, his atheistic standpoint demands that the Book of Genesis be treated as a fable, and that all ancient art or literature that tends to validate the events of Genesis, be treated as myth. If it means he must wrench away art from its historical significance and pry truth from its moorings, so be it.

Scores of authors have followed in the dark and murky paths carved out by Campbell and have thus been drawn into wasteful pseudo-intellectual excursions of their own. *Lady of the Beasts* by mutant author Buffie Johnson is one book among many which shows how the teachings of Campbell have limited and befogged many writers. In her book, Johnson features seventy pages devoted to the serpent in the ancient world. Over and over, she stresses the importance of the serpent. Over and over, she points to the connection between a woman, a tree, and a serpent; but she cannot see the Genesis connection. That is because her standpoint is

based on that of Campbell and other Slime-Snake-Monkey-Academics.

She features an illustration of the same Sumerian seal Campbell pictures in his book on Greek myth, and which I have discussed, above. Here is what she writes about it in her book: "Although there are similarities, the possibility that this could be an early version of the Adam and Eve story has been *denied* by archaeologists" [emphasis mine].

Note that she does not say that archaeologists have disproved it, or refuted it, but have denied it. All SSMAs must deny the possibility of an Eden, and deny every bit of evidence that suggests or points to a Creator; likewise, they must deny all the evidence which points to the inextricably related idea that the Book of Genesis is a true account of human origins. Their denials are a matter of atheistic dogma, not of science or logic.

In Section I, I wrote about how impressed I am with the information in the book, *The Myth of the Goddess*, even though the authors are SSMAs. Authors Baring and Cashford come very close to breaking out of the SSMA trap. They write that "the first 3 chapters of Genesis are *incomparably more beautiful* than the Babylonian myth of creation" [my emphasis], and that Genesis presents "a new way of perceiving the world, one in which creation is seen as the linear unfolding of an intelligible divine plan." Right on, sisters! Praise be to God!

But wait, for SSMAs to take a positive view of Genesis is taboo, and these authors know it. Calling them "vital to remember," they invoke these words of Joseph Campbell:

> **Wherever the poetry of myth is interpreted as biography, history or science, it is killed . . . it is never difficult to demonstrate that as science and history mythology is absurd . . . When a civilization begins to reinterpret its mythology in this way, the life goes out of it.**

As we've seen in the first three sections of this book, just the opposite is true. Once we see that what the mutants call "myth" is actually the history of our race, we develop true understanding of our origins. Life doesn't go out of the images in ancient art when viewed as history; it comes into them.

After settling back into the Slime-Snake-Monkey rut by quoting Campbell, the authors, as they must, do penance for their rashness and write: ". . . to reinterpret mythology solely in terms of the historical

events that may have given rise to it is to undervalue the numinosity of the image that still has the power to inspire and heal." What in God's world are they talking about here? Perhaps their trumping of history with "numinosity" is a corollary to this Joseph Campbell gem:

These mythic figurations are the "ancestral forms," the insubstantial archetypes, of all that is beheld by the eye as physically substantial, material things being understood as ephemeral concretions out of the energies of these noumena.

Such obtuse mystification tells us exactly where atheism and Slime-Snake-Monkeyism (SSMism) lead—nowhere. Paul referred to it as the "profane prattlings and antipathies of falsely named knowledge" (I Timothy 6:20). Let us here remind ourselves that ever since the Tower of Babel, fools have been posing as learned men.

The Religious Dogma of the Slime-Snake-Monkey-People

SSMPs assert that life began by a chance occurrence: matter suddenly turned into a living cell capable of reproducing itself. They cannot describe what specifically happened, how it happened, where it happened, why it happened, or when it happened. Thus, their adamant insistence that it happened despite the total absence of scientific evidence for it is a matter of faith, as absurd as that faith may be. If a man kept showing up at the police station, insisting that a crime had occurred, but could not say specifically what had happened, or how, when, why, or where it happened, he'd be charged with filing a false report, and most likely, be considered insane. SSMPs keep filing the same false report day after day. And this report is not based on scientific fact; it is what they believe—their anti-Creator dogma.

The SSMPs have their great prophet and apostle, Charles Darwin. While the apostle and prophet, Paul, represents Jesus Christ and His Father, the Supreme Spirit of Light and Love, Darwin represents Chance and Natural Selection (what he called survival of the fittest) operating over Time. As Christians worship Christ, SSMPs adore Darwin. In 2002, a group of well-known SSMPs published a book of essays exalting their prophet. They called it, *Darwin Day Collection One: The Single Best*

Idea, Ever. Darwin's "single best idea, ever" is a religious one, though it contrasts sharply with what Jesus said:

You shall be loving the Lord your God out of your whole heart, and out of your whole soul, and out of your whole comprehension, and out of your whole strength. This is the foremost precept. And the second is like it: You shall be loving your associate as yourself. Now greater than these is no other precept (Mark 12:30-31).

Which do you consider the greatest precept—loving your Creator heart and soul and your neighbor as yourself, or the idea that about a billion years ago, you began the process of mutating by chance from slime?

SSMPs have their living high priests. Their Grand Exalted Mutant today appears to be Oxford University professor Richard Dawkins, author of *The God Delusion*. The very title of his book should tell you that his focus is not on developing a systematic scientific approach to understanding nature, but on denying our Creator. He knows that the viewpoint he embraces is fundamentally religious: his first chapter is entitled, "A deeply religious believer in no God." SSMPs have a religious hierarchy under Dawkins in the scientific and academic worlds. And they even have their dark side counterparts to Sunday School teachers: the many biology teachers in our high schools—the mutants at the local level who thoughtlessly feed this speculative garbage to our children.

Like other primitive religions, SSMPs have their taboos. They are forbidden to consider a Creator or Intelligent Designer as a possible explanation for their observations in nature. I have never seen any evidence presented by SSMPs that justifies the exclusion of a Creator/Designer as a possible explanation for life on earth. Just as sound police work does not exclude suspects without evidence that they were not involved, sound science does not exclude possible explanations for what we observe in nature without presenting evidence for that exclusion. This in itself shows that SSMism is not true science in the sense of an open-minded, open-ended search for truth, but rather an exclusionary, dogmatic, religious philosophy of science.

SSMPs even have judges who make it taboo for parents and students to question the SSMism in our school system. In 2005, in Cobb County, Georgia, federal judge Clarence Cooper ruled that a school board's evo-

lution-disclaimer sticker had to be removed from science textbooks. This is what the sticker said:

This textbook contains material on evolution. Evolution is a theory, not a fact, regarding the origin of living things. This material should be approached with an open mind, studied carefully and critically considered.

Fear of this sticker reveals how insecure SSMPs really are about their religious philosophy of science. Any valid theory ought to be able to withstand the salutary tonic of a free current of public scrutiny.

SSMPs have their miracles, beginning with the one where molecules suddenly turn into a living cell. The second miracle is that this first cell came into being with the capability of reproducing itself. DNA is essentially a transmitter of information. Thus, their greatest miracle, more astounding than the virgin birth or turning water into wine, is the turning of molecules into information-carriers that enable a single cell formed by chance out of the "primordial soup," to change into a 60-trillion-cell, self-conscious human being, and at the same time to change into the millions of other life forms on this earth.

Chance has gifted SSMPs with a reverse form of prophecy. Although they often can't remember what they had for breakfast, they can look back through the mist of eons of time—30 million, 100 million, 500 million years ago—be absolutely certain that the earth existed then, and also tell us what kind of sex-dance our rat and snake "ancestors" were performing back then.

As part of their everyday religious rites, SSMPs employ magic. With deception worthy of the best of prestidigitators, SSMPs in general and Slime-Snake-Monkey-Journalists (SSMJs) in particular, have become adept at transmuting arrant evolutionary speculation into facts. I will document some of this presently.

Let me add one further observation about their religion. A fetish is something people irrationally and unquestioningly pursue or devote themselves to. SSMism is not logical or rational, and a believer is not allowed to question it. Those who devote themselves to what they call "the single best idea, ever" in reality embrace nothing more than a sacrosanct fetish.

Slime-Snake-Monkey-Journalists

Most of us do not read the pseudo-scientific reports by Slime-Snake-Monkey-Scientists. We learn about their work through the news media. SSMism has thoroughly polluted the media mainstream, producing SSMJs who routinely and systematically violate the most basic principles of their profession in their outright promotion of SSMism.

How did SSMA, Joseph Campbell, a man with virtually no under-standing of the origins of ancient cultures, come to be considered an ex-pert on the meaning of ancient art? SSMJ Bill Moyers made Campbell famous by presenting him as such on a PBS series entitled, *Joseph Campbell and the Power of Myth*. An estimated 30 million people watched the original presentation in 1988, and it has been re-aired often as part of PBS fund-raising efforts. There were no tough questions from Moyers, no probing the scores of obvious contradictions in Campbell's talk, and no skepticism—theoretically a hallmark of sound journalism.

Moyers is one of those doubly-deluded SSMJs, repeatedly insisting that he himself is a Christian. In *The Power of Myth*, Moyers is quoted as saying to Campbell, "Far from undermining my faith, your work in my-thology has liberated my faith from the cultural prisons to which it had been sentenced." One cannot be a Christian in any meaningful sense of the word, and promote as valid and edifying, the work of an atheistic Slime-Snake-Monkey-Academic. There are no mutants or Slime-Snake-Monkey-People in the body of Christ.

Now let's go to a March 17, 2005 *Washington Post* article by SSMJ Rick Weiss entitled, "Human X Chromosome Coded," with the sub-headline, "Sequence Confirms How Sex Evolved and Explains Some Male-Female Differences." Despite the promising sub-headline, Weiss presented no evidence at all confirming how "sex as we know it" evolved—just these two utterly speculative sentences:

It happened about 300 million years ago, long before the first mam-mals. A conventional chromosome in a forebear of humans—probably a reptile of some sort—apparently underwent a mutation that allowed it to direct the development of the sperm-producing testes.

Lucky for us that this very special "probably a reptile of some sort"

didn't get hit by a comet or choke to death on a catfish before its magical mutation; otherwise, today we wouldn't be enjoying "sex as we know it."

The editors of the *Washington Post* have written that the evidence for evolution is "overwhelming" and "powerful." How can the *Post* editors allow such arrant speculation to pass as overwhelming and powerful proof? The answer is that they "believe" in SSMism, and transmuting speculation into fact is one of their favorite religious rituals. SSMism is the only subject wherein they allow—even encourage—their reporters to break journalism's standard rules.

Suppose a sports reporter, under the headline "Washington Nationals Clinch World Series," wrote:

It happened around yesterday or a few days ago, probably in the bottom of the ninth, a ball-player of some sort may have gotten a game-winning hit, apparently to clinch the World Series.

That sports reporter would be fired that day for not knowing what he is writing about, for being incompetent.

Weiss' article gives us a prime example of the magical transmutation of speculation into fact. In the mainstream media, SSMism is always presented as fact and never proved, and Creationism is always denied, and never refuted.

Based on Weiss' article, other *Washington Post* SSMJs have falsely presented as fact to their readership that scientists have indeed confirmed how sex evolved, and that our X and Y chromosomes go back 300 million years to the reptiles who first engaged in sex. (If 300 million years doesn't seem like a long enough time for reptiles to morph into human beings, just add 50 or 100 or 300 million years). Such faux-reporting is dishonest and corrupting, and it evinces an unfathomable indifference to the principles of sound journalism.

On March 19, 2007, *Washington Post* mutant reporter, Shankar Vedantam, wrote about "our evolutionary predecessors" in the indicative mood; i.e., as a fact. He also wrote that "Biologists have shown that our arms and legs and organs have long evolutionary histories." There is absolutely no evidence for this—unless you consider that famous drawing of a fish crawling out of the water gradually turning into a man as some kind of evidence.

You would be outraged if the *Post* falsely published that your great-grandfather was a serial rapist or a child-molester. But when the *Post* says we all are descended from snakes, oh well. When little Johnny comes home from school and says he's descended from monkeys and reptiles, what can you say? The *Washington Post* has written that scientists have confirmed it as fact! Didn't you see the headline?

In *The New York Times*, the *LA Times*, on the *Discovery* and *National Geographic* channels—all over the country, mainstream journalists on the "science" beat have become unthinking propagandists for the religious philosophy of Slime-Snake-Monkeyism. On February 12, 2007, *Tampa Tribune* mutant reporter, Kurt Loft, wrote a revealing piece about the silk of the spider's web being studied by MIT. The web is made up of highly-reinforced nano-crystals spiders produce just before the silk sets. By weight, the web is stronger than steel, insoluble in water, resistant to bacteria, and chemically non-reactive. Here we have *prima facie* proof of design. But no. SSMJ Loft writes: "The MIT team hopes to replicate in a short time what spiders have developed over 350 million years."

Chance knows nothing of the strength of materials, or the mathematics and optimum specifications of web design. By chance, say 340 million years ago, did a spider spin its web out of rubber and go extinct because its prey kept bouncing off? Does that sound crazy to you? It should. At its core, SSMism is a crazy as can be.

Why don't spiders get stuck in their own webs? They exude an oil from their feet that enables them to walk across it. Are we to believe that the spiders who did not "evolve" this ability died stuck in their own snares, and that by chance, some spiders "evolved" that ability and survived? There is as much chance of a spider "evolving" the ability to walk on its own sticky web as there is of a human baby being born wearing a catcher's mitt and holding a baseball bat.

I challenge any SSMP to produce a diagram which shows, generation by generation, with detailed explanations, how a single cell evolved into a spider with its web or into a honey bee in its hive. Or how a single cell evolved into an oyster, a tick, a dolphin, a lightning bug, a giraffe, or any other creature for that matter. Oops, perhaps I shouldn't use the term "creature" because it implies creation. We need to coin another word that

fits the Slime-Snake-Monkey paradigm. How about "randomite"? By the way, what fortunate randomite chanced into having the first heart, and what made it start to beat at the correct intervals?

These SSMJs are college graduates. Some hold masters degrees in journalism. Has it never occurred to them that the key operative Darwinian phrase "natural selection" implies an agent of selection—a Selector? This is an obvious and fundamental embarrassment to Slime-Snake-Monkey "theory." Darwin's convoluted language drags the idea of the Creator right along with him into his own messy and contrary atheistic speculation. And what makes these SSMJs think that "random mutations" push in the direction of progress? Have they never played the daily lottery to realize that randomness turns out to our dismay most of the time? Can they explain what makes the random events of SSMism so different?

The Horrendous Implications of Slime-Snake-Monkeyism

Most SSMPs don't even think about the horrendous implications of their beliefs. We find the founding principle of our republic in these words of Thomas Jefferson in our Declaration of Independence:

We hold these truths to be self-evident, that all men are created equal, that they are endowed by their Creator with certain unalienable Rights, that among these are Life, Liberty and the pursuit of Happiness. — That to secure these rights, Governments are instituted among Men, deriving their just powers from the consent of the governed.

If there is no Creator, we are not endowed with "unalienable rights" of any kind, and we need to bulldoze the Jefferson Memorial. Not only are we revering an ignorant man, our form of government is built upon a lie. Shouldn't we build in its place a memorial to that prophet of random mutations, that son of the reptiles, Charles Darwin? In place of the Jefferson Memorial, why don't we erect a huge seated bronze statue of Darwin, with a snake in his lap and a monkey on his back? Please think deeply about this: if SSMism is true, as the scientists, academics, and journalists proclaim, give me one reason why we shouldn't replace Thomas Jefferson with Charles Darwin.

Along these same lines, let us consider what is (by coincidence?) the very central verse of the Bible, Psalms 118:8: "It is better to take refuge in Yahweh (God) than to trust in a human." Slime-Snake-Monkey-People believe just the opposite: "It is better to trust in a human than to take refuge in God." The question then becomes, what human? Hitler? Stalin? Karl Marx? Sigmund Freud? Mao Tse Tung? The Ayatollah? Fidel Castro? Charles Darwin?

The point is this: Slime-Snake-Monkeyism leads inexorably to the political and religious philosophy of "might makes right." All our so-called "rights" are alienable in the extreme when we take SSMism to its logical conclusion. There are no Creator-given rights, and without a Creator, everything is relative. There are no ultimate principles of right and wrong. Our "rights" are as chancy as our evolution from the slime.

And what does the notion of being products of random mutations at the deepest level of our genetic makeup really imply about our humanity? Random means "unpredictable," while a mutation is a deviation from the norm, the very definition of "aberration." Once there were chimpanzees. Millions of *unpredictable aberrations* later, there were humans. Billions upon billions of unpredictable aberrations take us back to that first cell, and to the slime before it. According to the Darwinist way of thinking, what, more than anything else, defines our humanity, our very essence as living beings? Unpredictable aberrations.

Summary

We have been way too timid in our criticism of what is essentially an evidence-shy, insane teaching of our origins. Jesus talked about the foolish man who built his house upon sand. At least sand offers *some* support. When we get back to the very foundation of Slime-Snake-Monkeyism, there is *nothing* there. Molecules of matter do not turn into information on their own. Darwin's God-denying, infectious pretense has developed into a ludicrous consensus which denies contrary evidence, impedes the search for truth, destroys intellectual integrity, and muzzles scientific curiosity.

The scientifically correct way to approach the truth of our origins is

to gather all the evidence we can, study it, and logically evaluate whether the facts point to chance or to a Creator/Designer. Darwinism is not about an authentic approach to science. It is about Herakles, with the help of Athena, pushing away the heavens, and with them, the God of the heavens, exalting man as the measure of all things. It is the way of Kain.

We should refer routinely to those who embrace evolution as what they believe they are: Slime-Snake-Monkey-People. Calling them Darwinists, evolutionists or naturalists imparts to them an undeserved dignity. They themselves profess to be mutants. What they believe is not intellectually factual, just intellectually fashionable. Their doctrine is loaded with preposterous assertions, ludicrous incongruities, and farcical proofs. Let us hold them up to merited ridicule.

We are created beings living in a creation. Sit in your yard or go to a park and look around: it is design that distinguishes the species, not chance. Like our unalienable rights, this too is self-evident. Paul wrote that we know intuitively of the Creator by His achievements. From Paul's standpoint, SSMPs are those who "alter the truth of God into the lie, and are venerated, and offer divine service to the creature rather than the Creator" (Romans 1:25). Paul also wrote this about them: "Alleging themselves to be wise, they are made stupid, and they change the glory of the incorruptible God into the likeness of an image of a corruptible human being and flying creatures and quadrupeds and reptiles" (Romans 1:23). Here is the ultimate irony of SSMism: when humans push our Creator out of the picture and exalt themselves as supreme, they begin insisting that snakes are their ancestors. The next time you run into a Slime-Snake-Monkey-Person, ask him or her to repeat out loud, with conviction: "Three hundred million years ago, two reptiles had sex; therefore, I am."

The hallmark of a healthy humanity is a genuine connection to the truth of our historical identity. SSMPs do not have that connection. They embrace a false, fixed belief—a delusion—concerning who they are and where they come from. SSMPs try to purify and protect their delusion by excluding evidence that challenges and contradicts the many systematized fabrications populating their imaginations. They find the witness of humanity's origins recorded in the Book of Genesis and in ancient art

very threatening. That is why they must treat the former as a fairy tale, and the latter as myth. Understanding what is portrayed by ancient art validates the Book of Genesis which in turn validates the existence of the God of Genesis. Acknowledging the God of Genesis forces a recognition of mankind's utter stupidity in relation to Him. Next comes humility, and the admission that Darwin's speculation is, to put it mildly, asinine.

I must add something in regard to mankind's stupidity without God. Darwin published *The Origin of Species* in 1859, a time when the fashionable world was especially hungry for writings that "proved" the Scriptures false. In 1860, the Frenchman, Ernest Renan, also fed that desire by publishing *The Life of Jesus*, a weak biography that made Jesus out to be just a rather exceptional man, and not the Son of God. The intelligentsia (read: the *idiotica*) ate up Darwin's and Renan's writings.

The interesting thing is what else Renan wrote: an ode to Athena. Some key excerpts: "The world will never be saved unless it returns to thee . . . I will adore none but thee," and in perverted imitation of King David's words in Psalm 84:10, "I would rather be last in thy house than first elsewhere." How urbane and progressive to make an object of devotion out of an idol representing Naamah, the dead sister of Tubal-kain!

Is it any less pathetic a delusion when the mutant randomites make Charles Darwin and pseudo-science the dumb idols of their adoration?

Those who believe that they are Slime-Snake-Monkey-People are under strong delusion. I pray this book in some small way helps break that delusion, and that God, by His grace, will enable many "to come into a realization of the truth . . . sobering up out of the trap of the Adversary, having been caught alive by him, for that one's will" (II Timothy 2:26).

———

APPENDIX

Where Noah's Ark Landed

I had the good fortune of coming across the book, *The Stars: A New Way to See Them* by H. A. Rey some time ago. Rey's book helped me understand the relationship between the earth's daily rotation, its yearly revolution around the sun, and the place and appearance of the constellations. When I share my knowledge of the night sky with others, I begin by asking if anyone in the group can find the North Star because it is our frame of reference for what appears elsewhere. Almost invariably, someone in the group says, "The North Star is the brightest star, isn't it?" Polaris is certainly visible to the naked eye, but as a second magnitude star in Ursa Minor, it is very far from the brightest. There is no logical reason to assume that the earth's axis conveniently points to the brightest star, yet people make that unwarranted assumption all the time.

A similar illogical and unwarranted assumption prevails relating to the landing spot of Noah's ark. People—highly-educated people—are sure that Noah's ark landed on the remote and inaccessible heights of Mount Ararat, a 17,000-foot volcanic mountain in modern-day Turkey. The Book of Genesis does not say that the ark landed near the top of Mount Ararat, or even on Mount Ararat, but rather "on the mountains of Ararat" (Genesis 8:4).

Think about it: if you were Noah, would you land a huge craft full of animals, tools and supplies near the top of the highest, craggiest peak in the mountain chain? Why would you land your ship and everything you've brought from the pre-Flood world in an extremely precarious location? Wouldn't you want to live in the ark until you made suitable habitations nearby? Wouldn't you want to use the ark wood to build those habitations? Landing the ark on Mount Ararat makes as much sense as mooring a yacht in the middle of a swamp.

In *Noah's Ark—The Evidence: The Bible, The Flood, Gilgamesh & The Mother Goddess Origins*, David Allen Deal presents a common-sense, convincing argument, based on fact after fact, that Noah's ark landed on an 8,000-foot mountain seventeen miles south of Mount Ara-

rat. I summarize here just a few of the surprising things David Deal has uncovered. With his permission, I use mostly phrases and sentences from his book.

The ark first landed on the mountain south of Ararat in a welcoming and accessible spot at an elevation of 7400 feet (see arrow in illustration, opposite). The hull of the ark provided basic raw materials for the occupants of the first post-Flood city, Mesha-Naxuan. They stripped its planks and beams to build roofs, and used the melted down *kapar* or bitumen (tar) to seal the roofs from rain. They most likely used the wood for furnishings as well as fires. When the ark slid down hill after an earthquake and rains provided the impetus, perhaps after 100 years, the Mesha-Naxuan lumber yard moved a mile across the mountain, and 1,200 feet lower. Two ark impressions remain on the mountain: one where it landed, and the other where it descended to the lower elevation. Evidence on site indicates that the ark slid down the mountain, away from Mesha-Naxuan, after about 1,000 dwellings had been built there.

Mesha means "to be drawn out of water" which is the name most likely given to it by Noah. *Nax-xuan* is a Greek interpretation for the Hebrew, *noach tsywn*, "Noah's Zion," or "Noah's capital," obviously a name given to the city by later generations.

Mesha is a variation of *Moshe* meaning "saved through water" as Moses (Moshe in Hebrew) was saved from the Nile. In the ancient *Epic of Gilgamesh*, Gilgamesh (Nimrod/Herakles) traveled to the mountains of *Mashu* to find Utnapishtim (Noah/Nereus), the man who had come through the Flood. Gilgamesh (Gl-Gm-Mesh) means "the man who revealed Mesha."

Genesis 10:21 refers to Noah's son, Shem, as the "forefather of all the sons of Eber." They were said to dwell "toward Sephar, a mountain of the East," having come "from Mesha" (Genesis 10:30).

The traditional Kurdish names for the mountain today are *Masher Dag* and *Mashur Dag* meaning respectfully doomsday mountain and resurrection mountain.

In Shemitic (from Noah's son, Shem), the place where Noah dwelt was also called *Dilmun* which means "the abode of the dangling (dried-up)," a fitting epithet for those left high and dry on the mountain after the

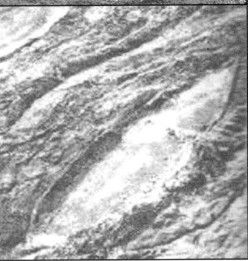

Above we see the mountain 17 miles south of Mt. Ararat where the ark originally landed (arrow), and the impression it left when it slid down the mountain about 100 years later. To the right, we see the ark impression as it appears from the air. At the top of the mountain, we see the escarpment cliffs which the *Epic of Gilgamesh* refers to as the "wall of heaven."

As for the ark itself, nothing remains of the wood, unless petrified material still lies buried inside the earthen structure. The Turkish government officially recognizes it as *Nuh'un Gemisi*, or Noah's Ark, and yet many resist its proper identification. Turkey refuses to let archaeologists excavate to determine authenticity. You can decide for yourself after reviewing the evidence presented in Dave Deal's book.

world-wide Flood. Both names, Mesha and Dilmun, attest to Noah's salvation from the Flood at this location. The *Epic of Gilgamesh* refers to the "wall of heaven" on Mount Mashu. You can see that wall, in the form of escarpment cliffs, in Dave Deal's photo on the previous page, and in his drawing, opposite.

Mesha-Naxuan was the very first city of our post-Flood civilization, built by Noah and his sons and their sons, from materials scavenged from the ark, long lost to the world but mentioned in many historical accounts.

In a footnote in *Antiquities of the Jews* by Flavius Josephus, translator William Whiston says that Noah's landing and dwelling spot was called "Naxuan, the place of the first descent." Here he quoted Armenian historian, Moses of Chronensis. This phrase "place of first descent," implies a second descent, and that is exactly what the evidence on the mountain itself is telling us. The city of Mesha-Naxuan was the first "city" built by the flood survivors and their descendants. Then from an earthquake and rain, the ark slid down 1200 feet to its second and final resting place, leaving what is now a one-acre elliptical 538-foot-long ship's hull impression at 6,200 feet.

Most or all of Noah's offspring abandoned Mesha-Naxuan and built a new settlement where the ark came to rest. This second town built after the Flood was originally called Seron because of the *Tsar* or sharp outcropping that penetrated and arrested the downhill slide of the ark hull remains. The "sar" part of the name remained in the later place names: Ni-sar and Na-sar. The Babylonians referred to the town as Nisir.

While mountain adventurers still climb Ararat, David Deal and a small unconnected group of other people have begun to realize the implications of this site at Mashur Dag, having seen the evidence for what it is. The ark mold impression is compelling as a stand-alone feature. The remnants of many ancient habitations discovered by Deal in 1996-1997 at the upper landing site (Mesha-Naxuan) and the "wall of heaven" written of in the *Epic of Gilgamesh* convincingly add to the evidence. Furthermore, the connected meanings of the various place-names on the mountain provide us with a unifying clarity. As the entire mountain location is now becoming known and understood, it is impossible to conceive of the ark landing anywhere else, especially on a massive volcano.

Sketch of the landing site on Mashu or Mesha Mountain as the survivors began to construct the first city—Mesha. The ark was used to secure building materials such as wood for roofing and tar for sealing the roofs. Noah's agricultural patch appears on the plateau. At present, this patch of ground harbors many types of plants that grow here profusely; but outside the perimeter of the small field, almost none of these plants appears. This patch shows up on aerial photos and cannot be easily explained except to say it was at one time a small field—perhaps for the grapes that Noah used to make his wine.

What I have written here barely scratches the surface of what Dave Deal has uncovered. For more information, please go to:

noahsark-naxuan.com